D1369339

WITHDRAWN

AMELIA
&
the ANIMALS

AMELIA & the ANIMALS

PHOTOGRAPHS BY Robin Schwartz

FOREWORD BY Amelia Paul Forman
ESSAY BY Donna Gustafson

aperture

FOREWORD

/

BY AMELIA PAUL FORMAN

I'm a girl named after a capuchin monkey.

She was the first monkey I was ever photographed with, when I was two. Maybe she sparked my love for nonhuman primates, which has led to unimaginable experiences for a city kid. It seems like something out of a fairy tale—a girl with an affinity for the animals that surround her. But that is the story in the photos. Behind the fairy tales are the real, amazing, tame animals that I have gotten to know.

I was three years old when I first looked into a chimp's eyes. Mom told me, "You two fell off the chair hugging." My mom, Robin Schwartz, is a photographer. I am her model. Her first book was of portraits of primates, so she knows people with monkeys. When I look back on all the things that holding that chimp started, it amazes me. There was the book *Amelia's World*, made up of photographs of me with different animals. There was also the time I spoke in front of a thousand people at LOOK3, a photo festival in Charlottesville, Virginia, to make an appeal for koko.org, a foundation dedicated to bringing interspecies communication to the public and to save gorillas from extinction. Pictures of me have been published in the *New York Times Magazine*, and my writing about them has been published on the *New Yorker* blog. This past summer, I held a white tiger cub, a baby chimp, an armadillo, gibbon apes (my favorite), and many capuchin monkeys.

This is why my mom and I found ourselves in a broken-down car somewhere in Ohio, a few years ago. We had been driving from New Jersey to the Midwest, where we were visiting a sanctuary with primates. Every once in a while, I would ask, "How much longer?" Each minute seemed like an hour and I was getting hungry. I closed my eyes knowing that the sometimes-bad food and weird motels were outweighed by what I was going to do: play with a baby chimp and hold an armadillo, as well as other animals.

Mom was frantically trying to find our location on Google Maps when a state trooper came up to the car window. He must have thought we were strange because the monkey toys we had brought as gifts were in the front seat staring back at him. The state trooper called AAA, and minutes later

we were sitting three across in a truck. Our car was on a flatbed behind us, being towed to Pep Boys. The fuel gauge was broken. The mechanics fixed the car and we were back on the road.

When our GPS said, "Arriving at destination on left," I breathed a sigh of relief. I saw emus strutting on the hard dirt, miniature horses gobbling up some carrots on the ground, peacocks trying to show off their beautiful feathers (and succeeding), and chimps laughing with pure joy as they swung on a tire and threw a ball back and forth. I saw a huge cage with two gibbons swinging side to side, their arms longer than their bodies. We were greeted by my mom's friend, who runs the sanctuary, and invited in. We pulled the big cases of photo equipment out of the car and headed inside.

Mom and I walked into a room full of stuff, but all I saw was the baby chimpanzee named Tash, in a crib. Looking down at him I was captivated by his eyes, so big and brown. I was amazed. I picked Tash up and lay down on the couch with him. His hands were so soft holding onto my thumb. My mom took pictures of us. Later we played games on my iPad and Tash took pictures of my mom and I.

Monkeys are always my favorite animals to be photographed with. I will always remember the feeling of being with nonhuman primates. They are so similar to us that they cannot compare to dealing with other animals. When I was ten years old, my mom and I flew to Texas. I remember the plane taking off, one of my favorite feelings. The land below was a constellation made up of streets and highways. I knew that I was off to Texas to visit monkeys, but did not know what else to expect. I went to Pam's house, one of Mom's friends. Pam is a wonderfully generous person with a huge smile and bigger heart. She had just adopted a seven-month-old white-faced capuchin monkey named Rosie. While my mom talked with Pam, I was allowed to play with Rosie. Pam gave me a few string beans and asked if I would like to feed Rosie. Pam said, "She has not quite gotten how to eat solid foods yet, but you can try." I gave Rosie a bean, and took one for myself. I showed her how to open the bean; Rosie opened hers with her tiny hands, but did not know what to do with it. I showed her how to eat

it. Something must have clicked because she ate her bean. It was exciting walking Rosie through the steps, knowing that I could communicate with her. Learning how to eat a bean seems like something so small, but it's amazing when it actually happens. I knew that I had taught a fellow primate something.

When I was three, I was the subject of my mom's photography. Now I have learned to collaborate with her. During the photo shoot at the chimp sanctuary, I suggested to Mom that she take pictures of me standing up with the baby chimp, cheek-to-cheek. The pose was like that first picture of Ricky and me eleven years ago, the one that started the photo project and was on the cover of the first book. My mom took the pictures. Those were the ones from the shoot that made the edit.

Ricky and Amelia 2002

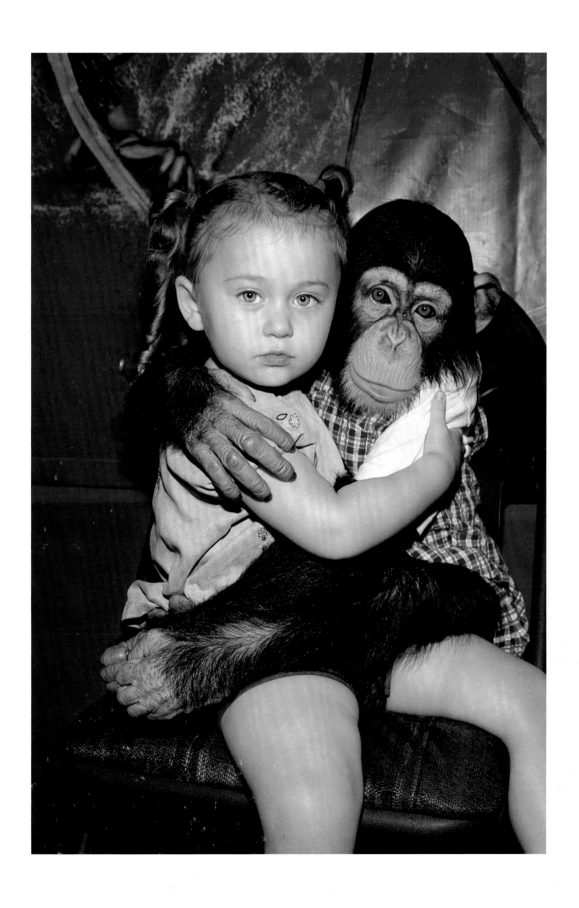

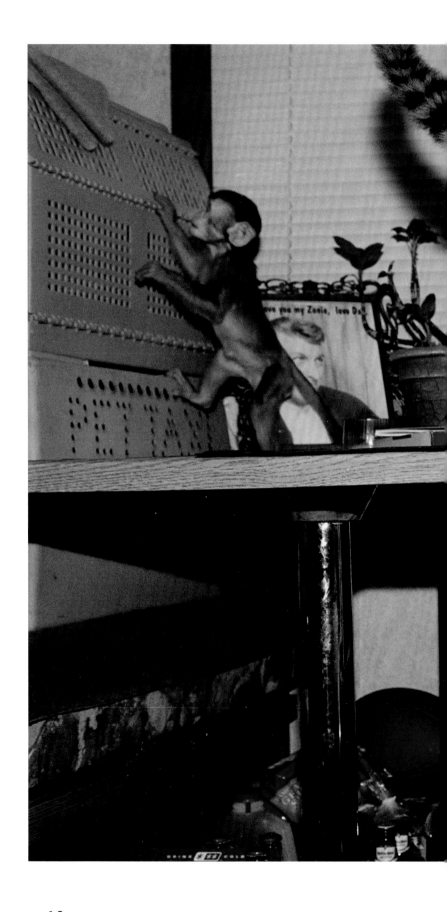

Elmo, Amelia, and Abu 2002

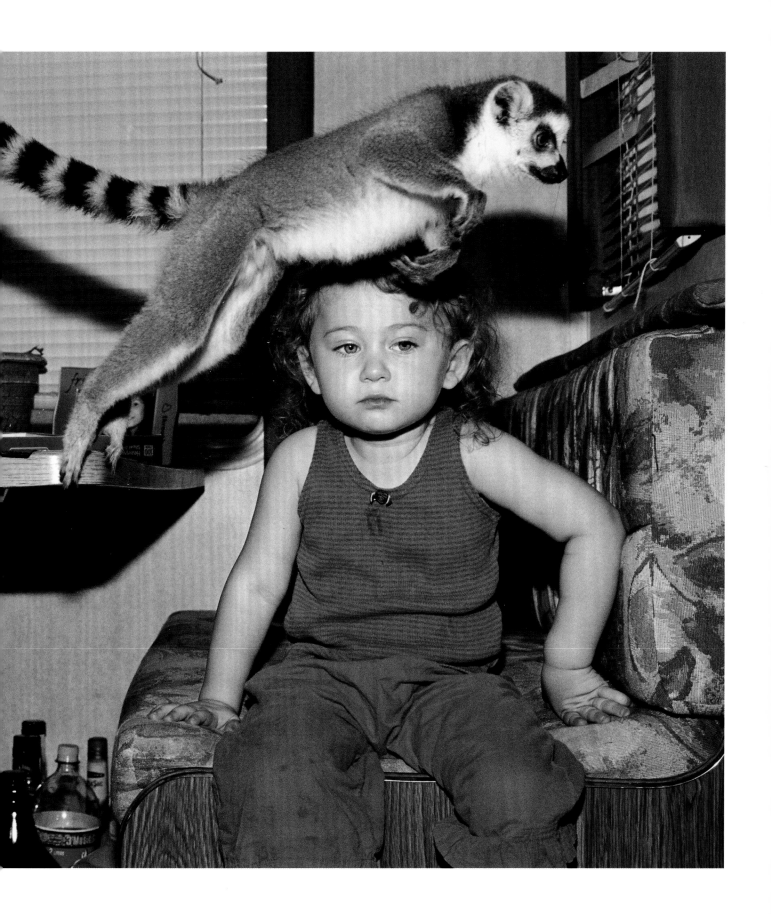

Jacob and Amelia 2003

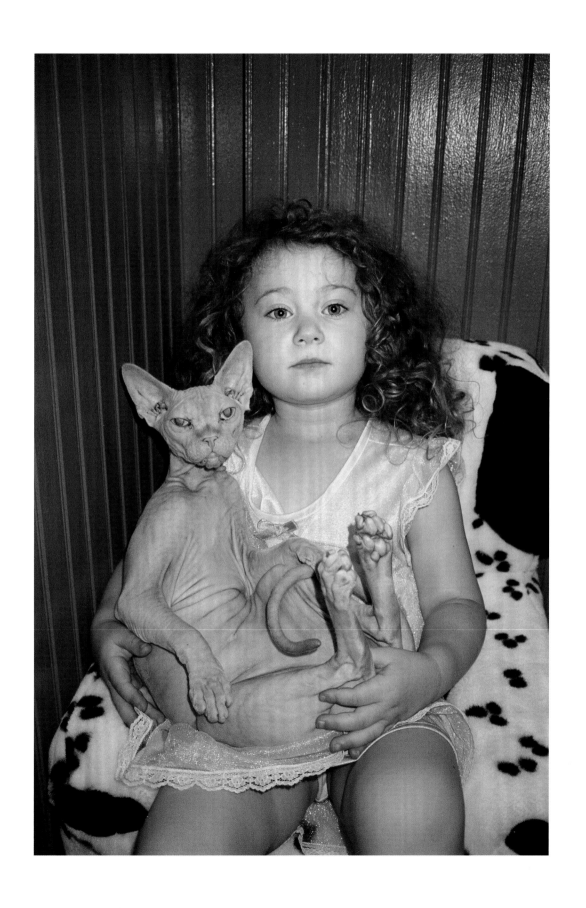

Rebecca and Amelia 2003

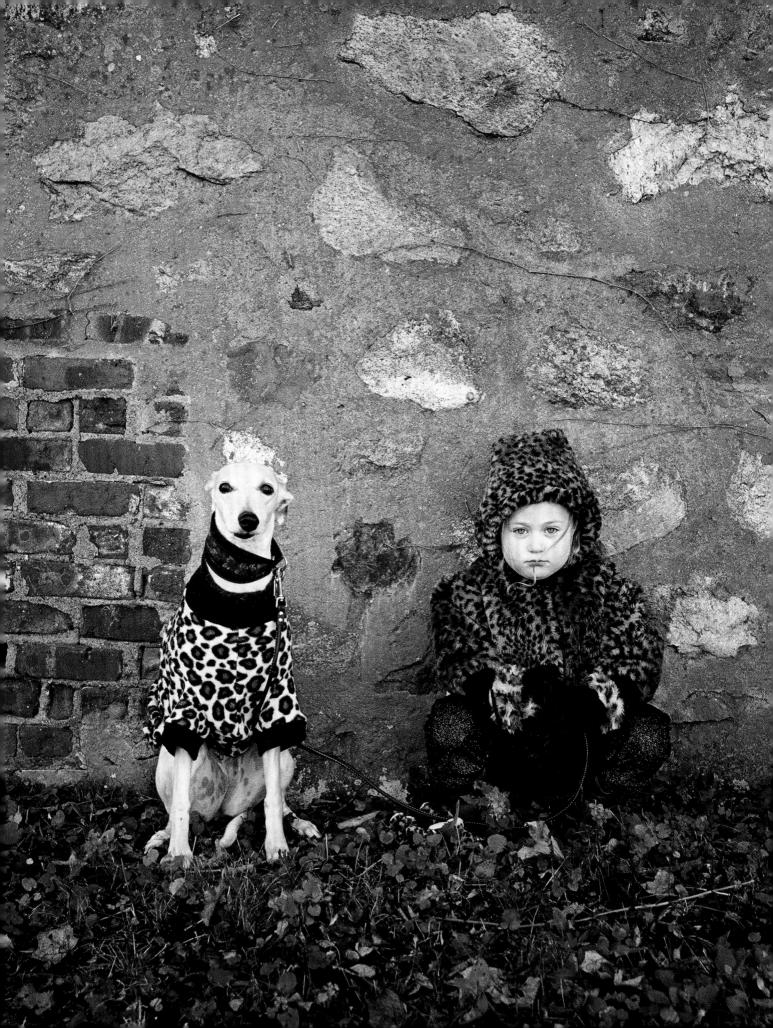

Amelia and Little Amelia 2003

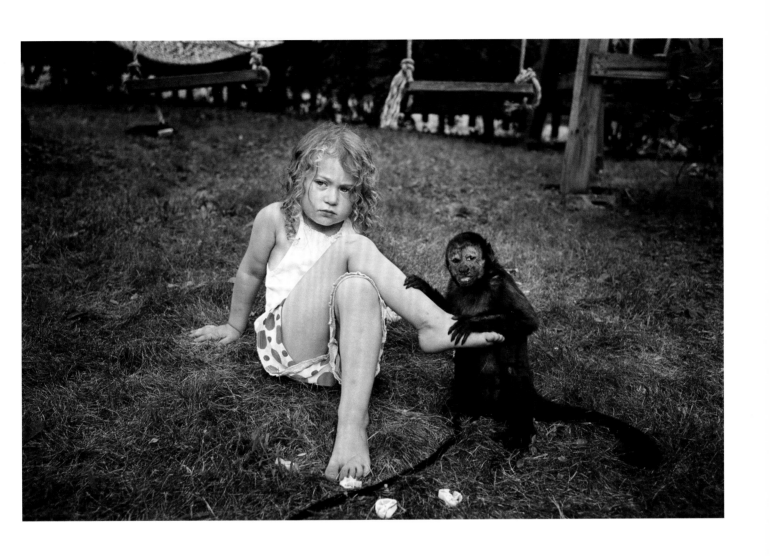

Sandy Adler's Sphynx Cats 2004

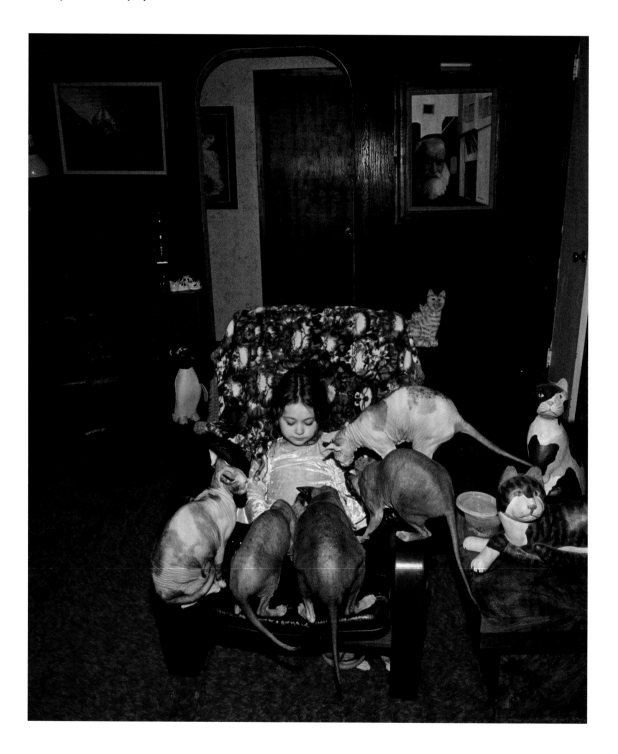

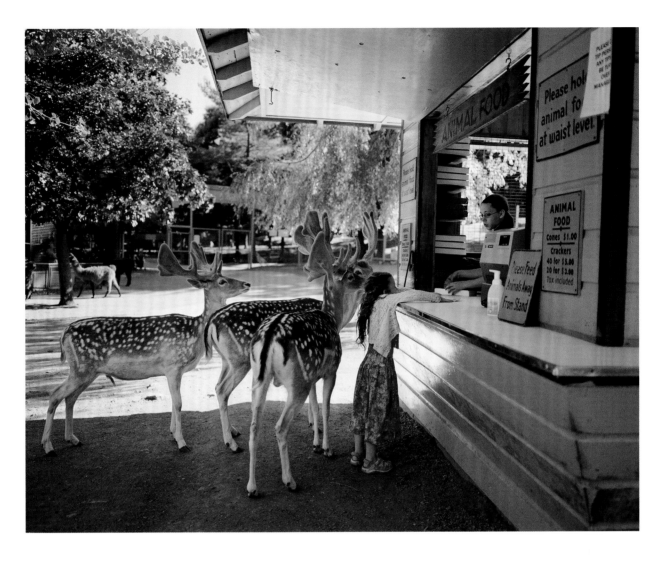

Deerline 2005

Monkey Family 2005

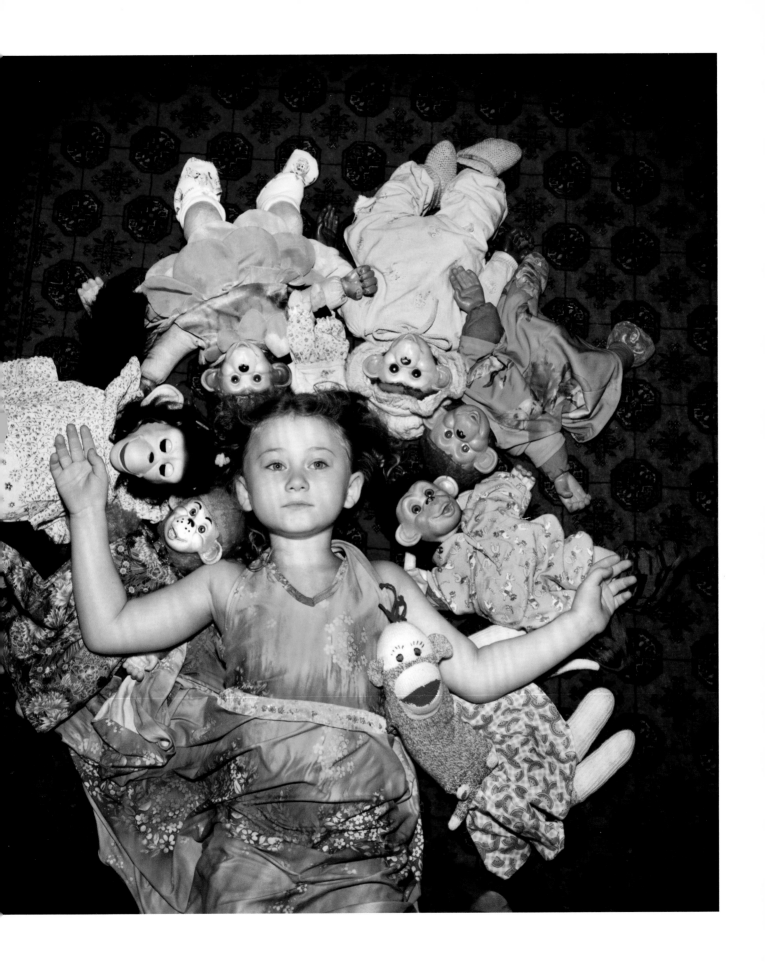

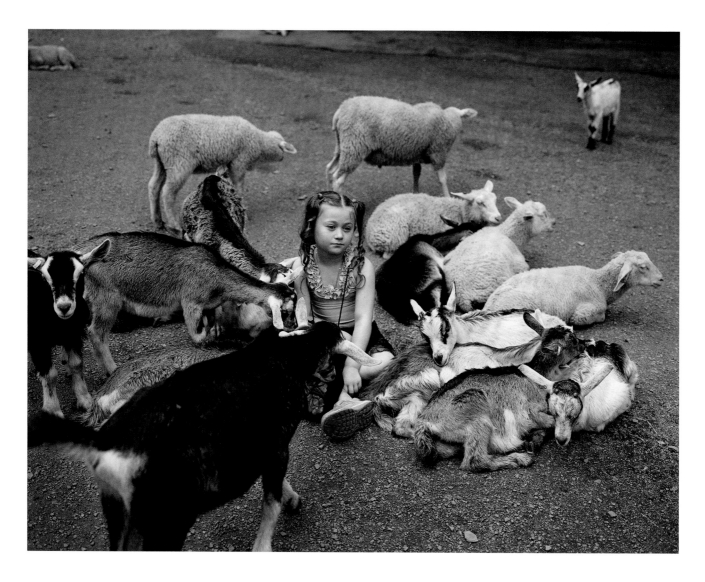

Kids 2005

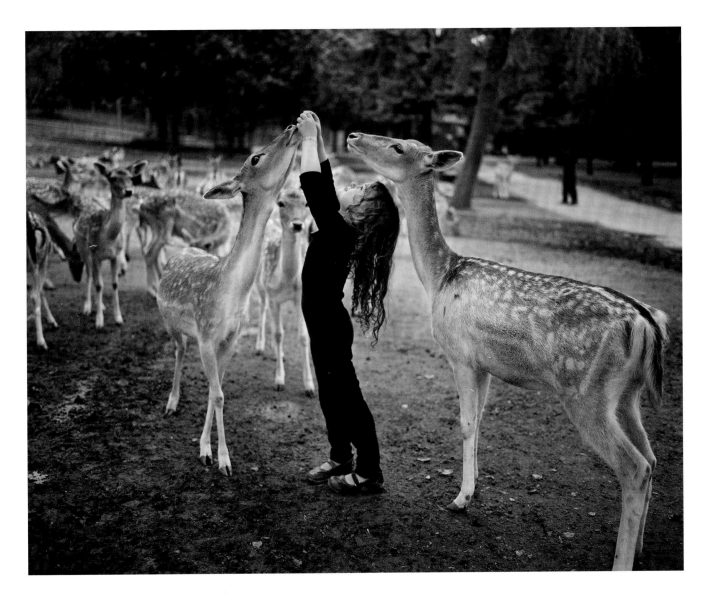

Reaching 2005

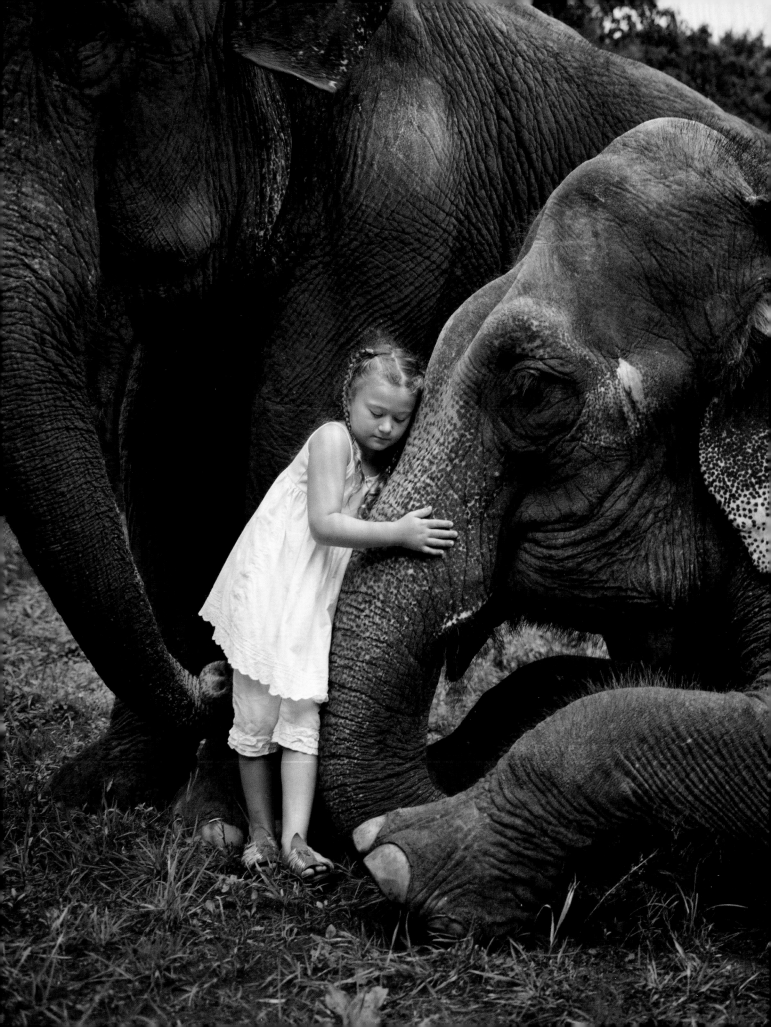

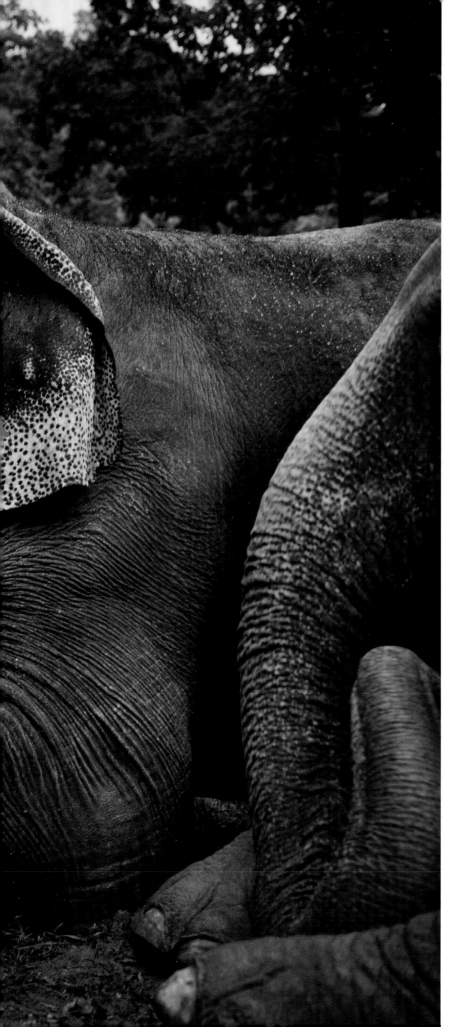

Trunk Sniff 2005

Firehouse Stairway 2005

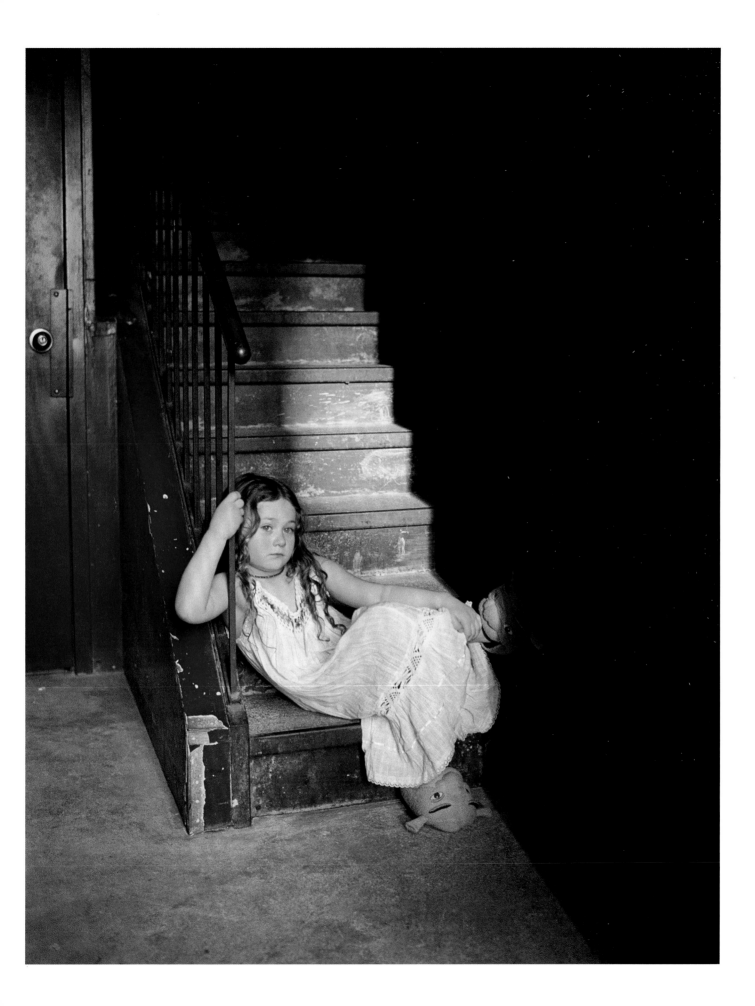

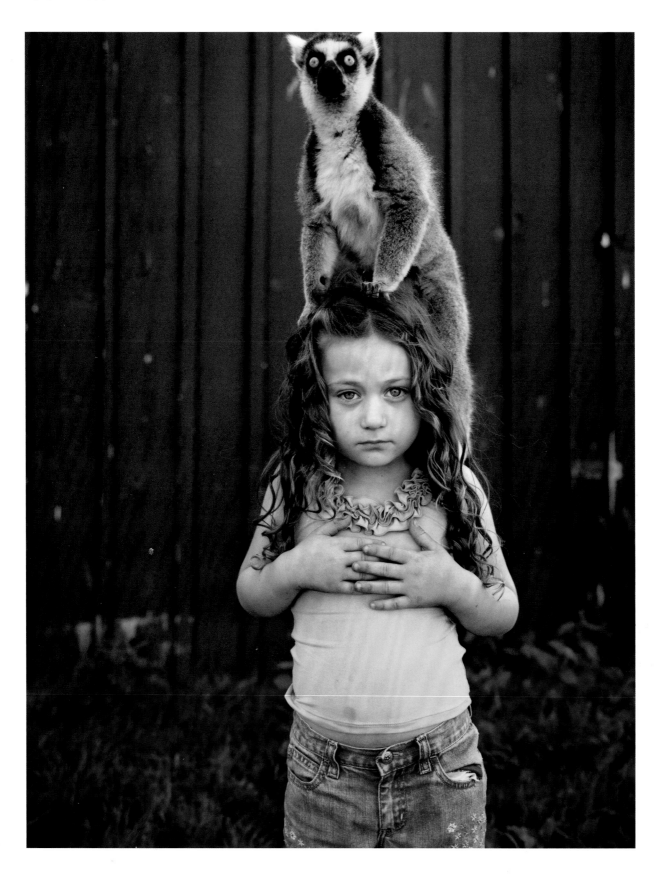

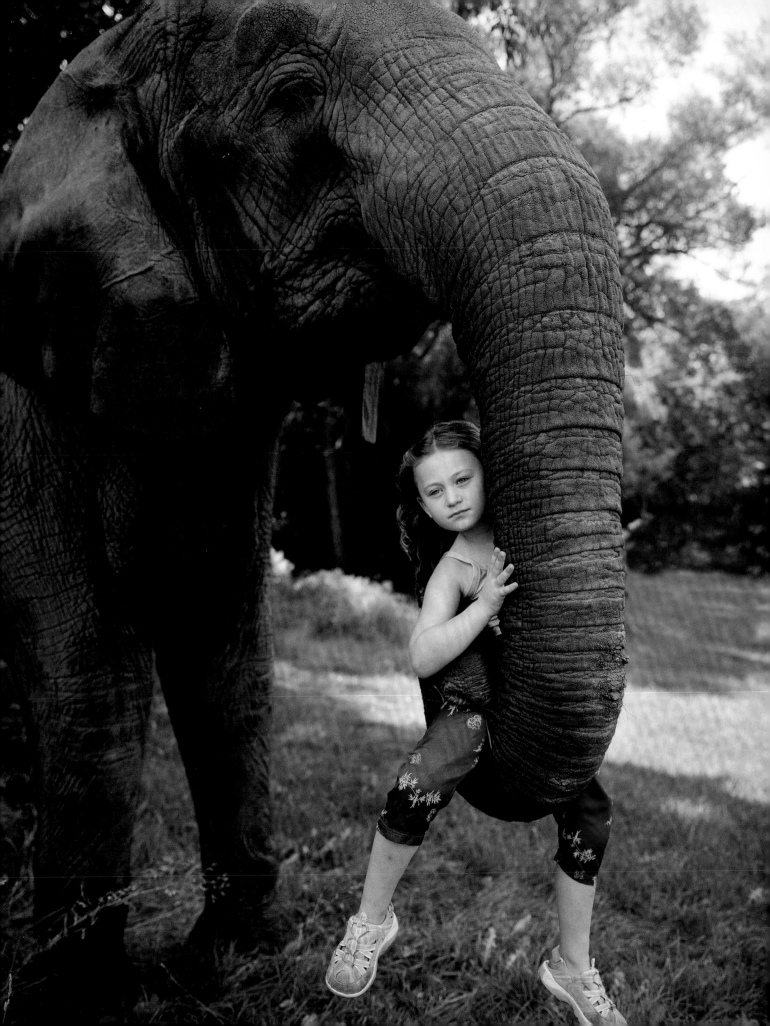

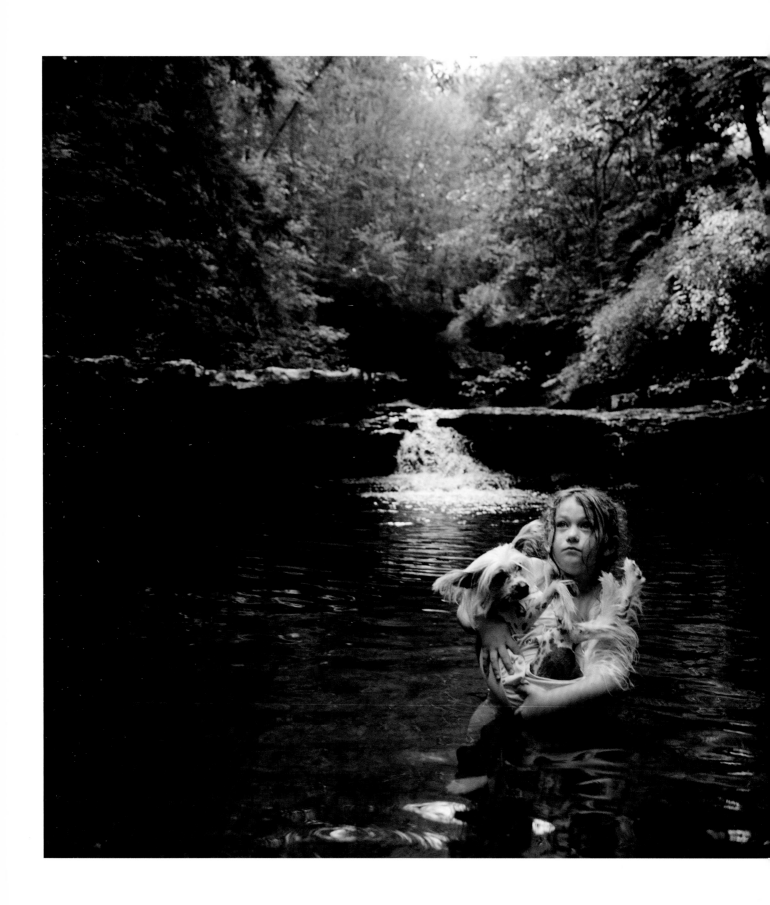

Carriage House Waterfalls, Nora 2006

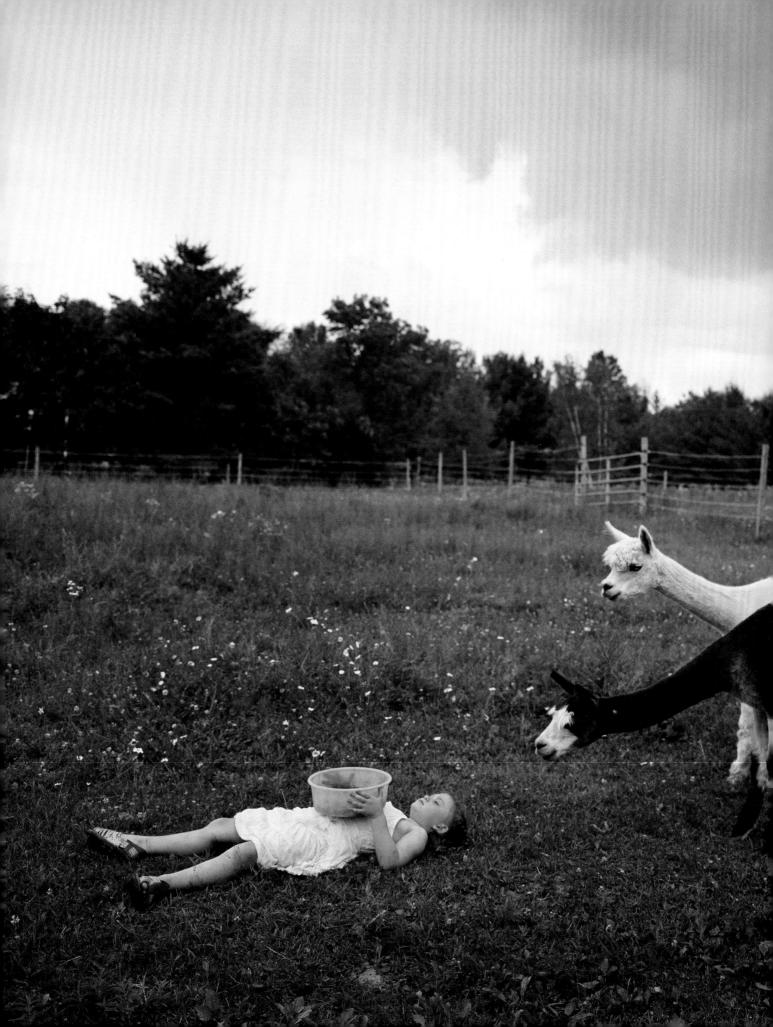

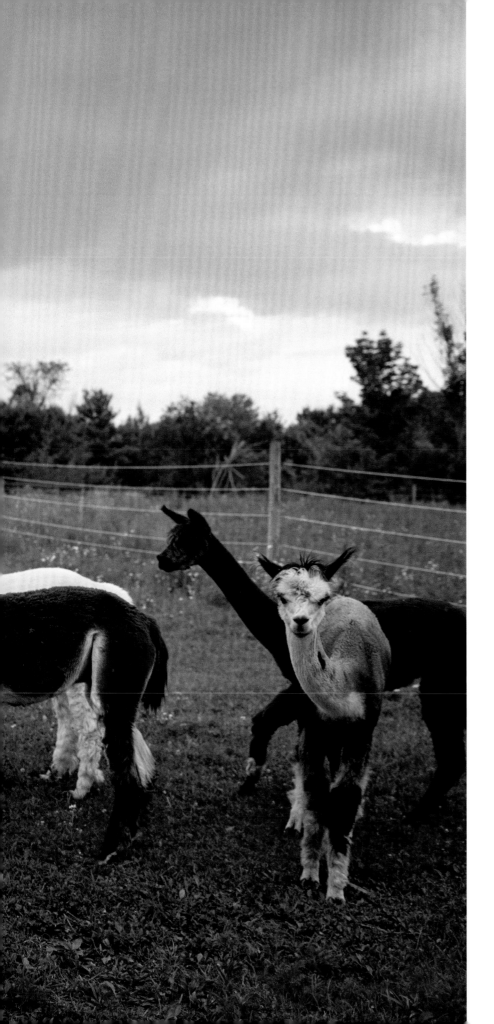

Feeding Flat 2006

Maya Blue 2006

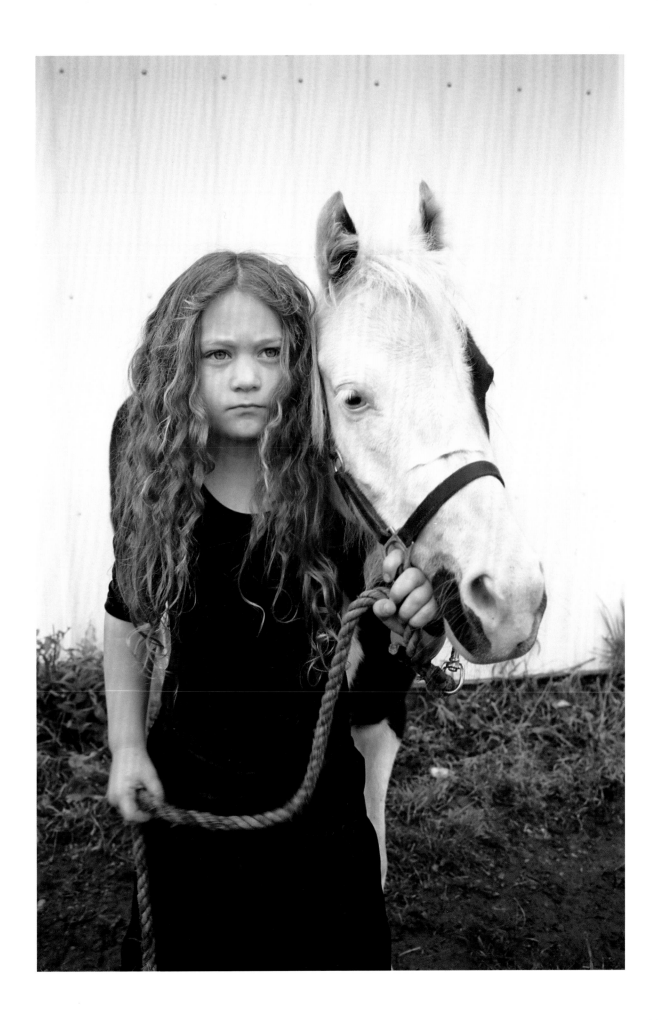

Tower, Jacob 2006

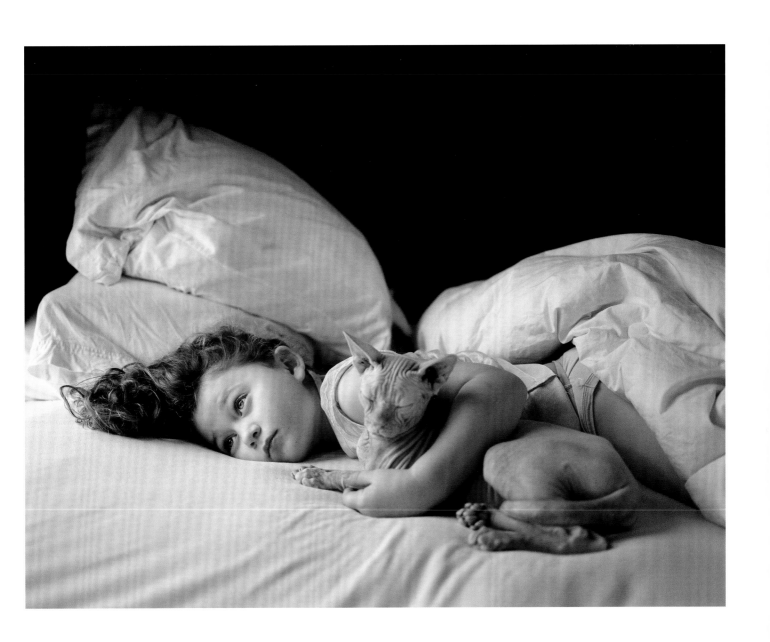

Walter's Forest 2007

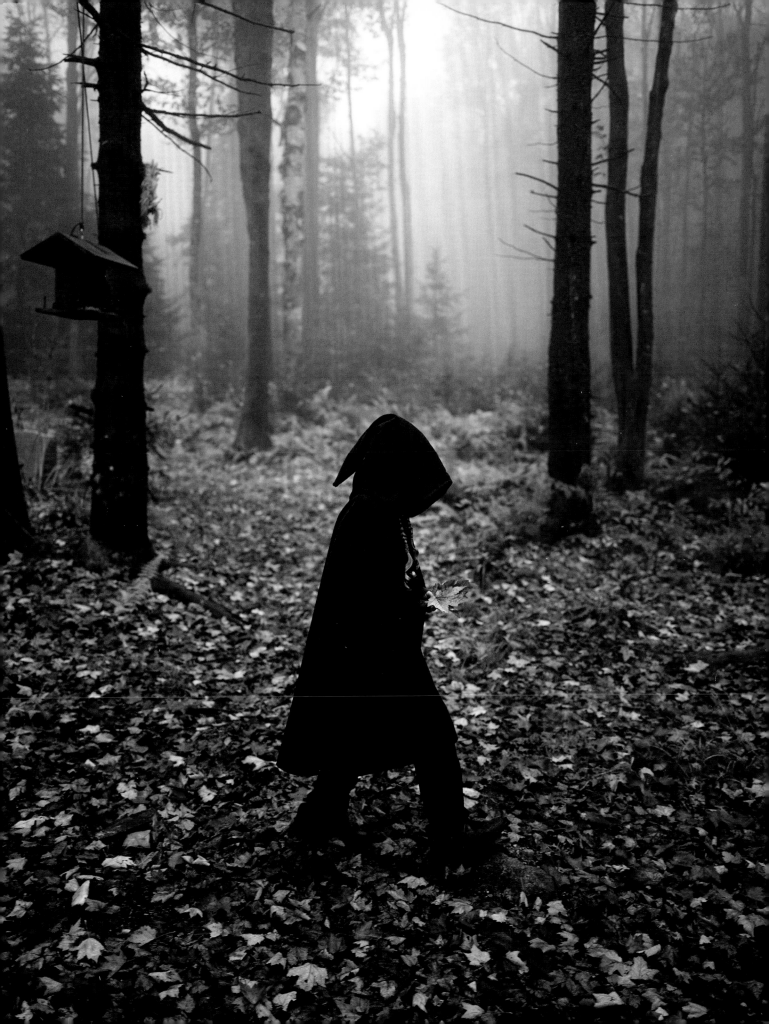

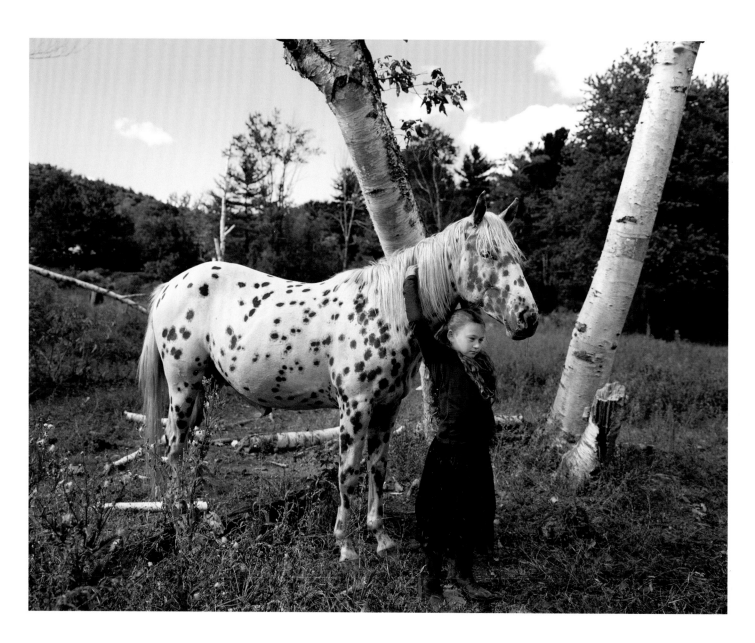

Carbon, Hug 2007

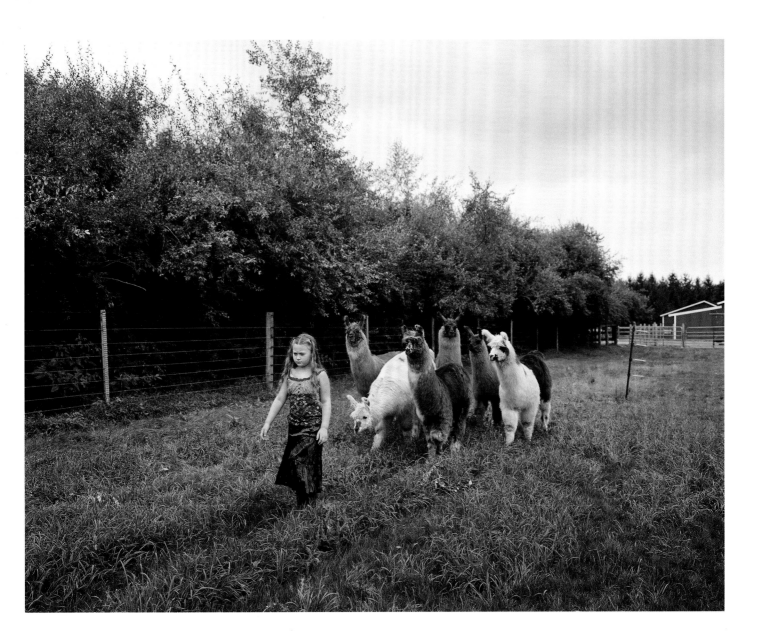

Spruce Lane Llamas Follow 2007

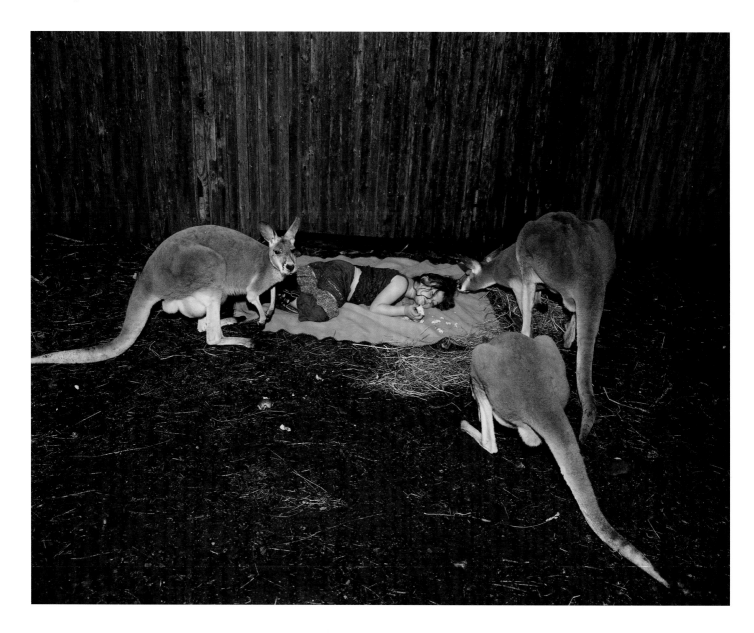

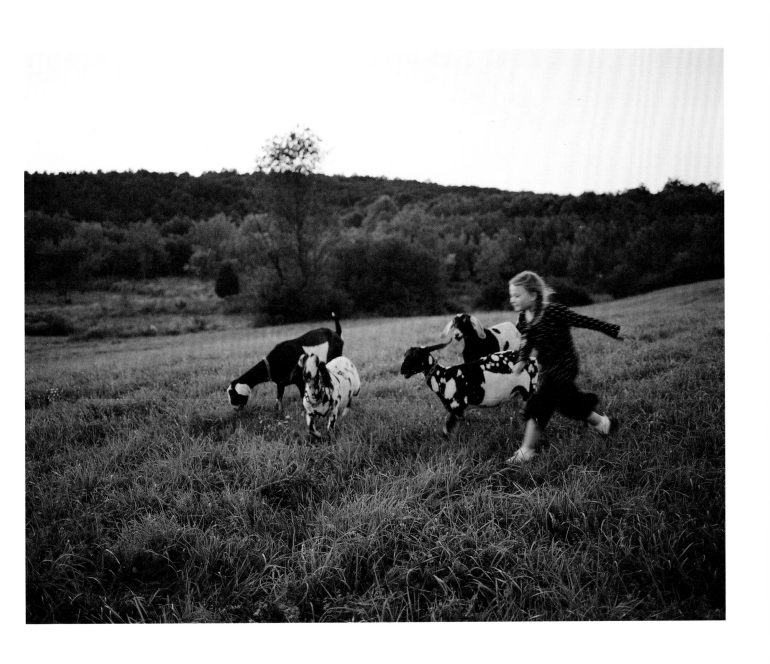

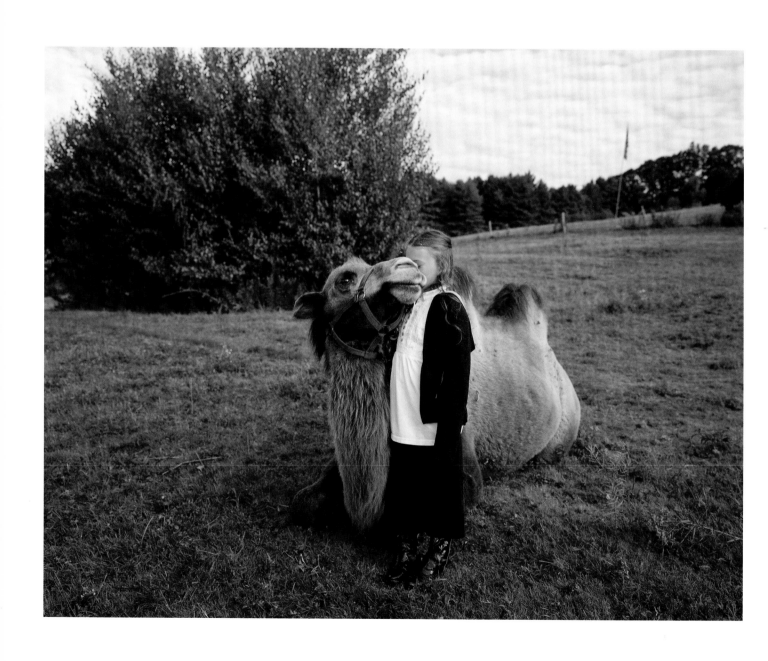

Durshur Face Rub 2007

Louie 2007

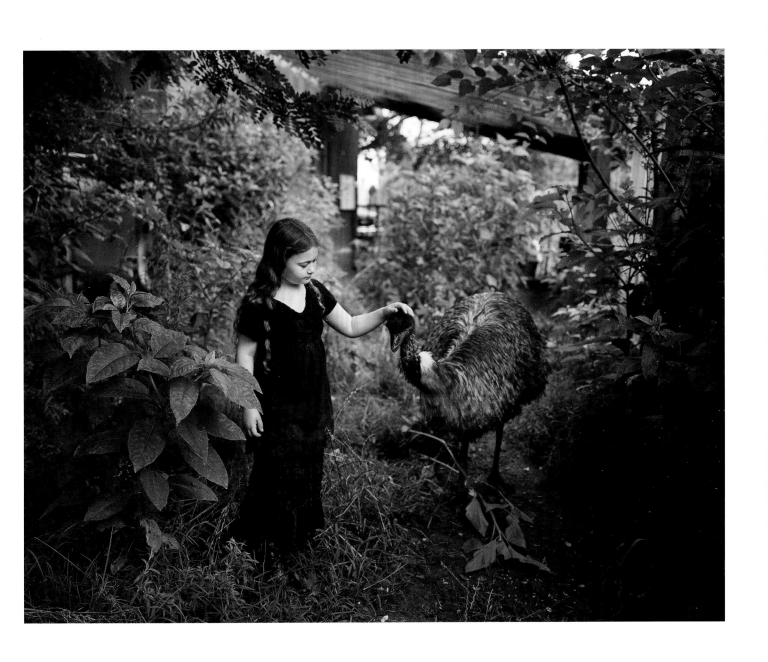

Morning 2007

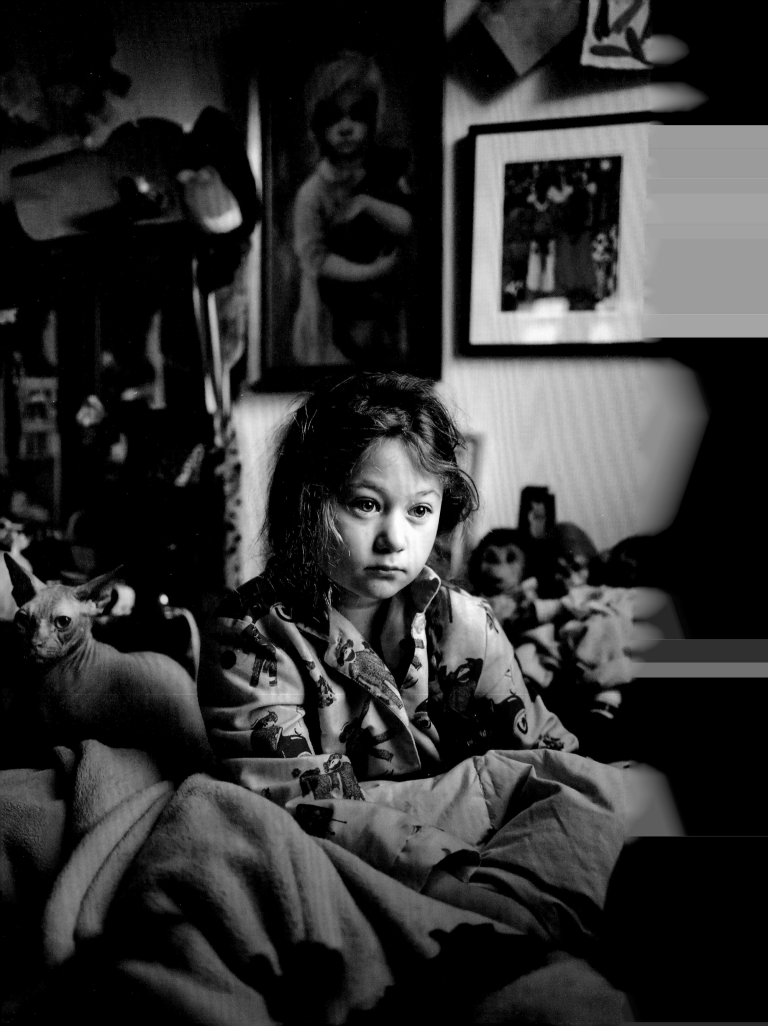

Geoffrey and Twigs 2008

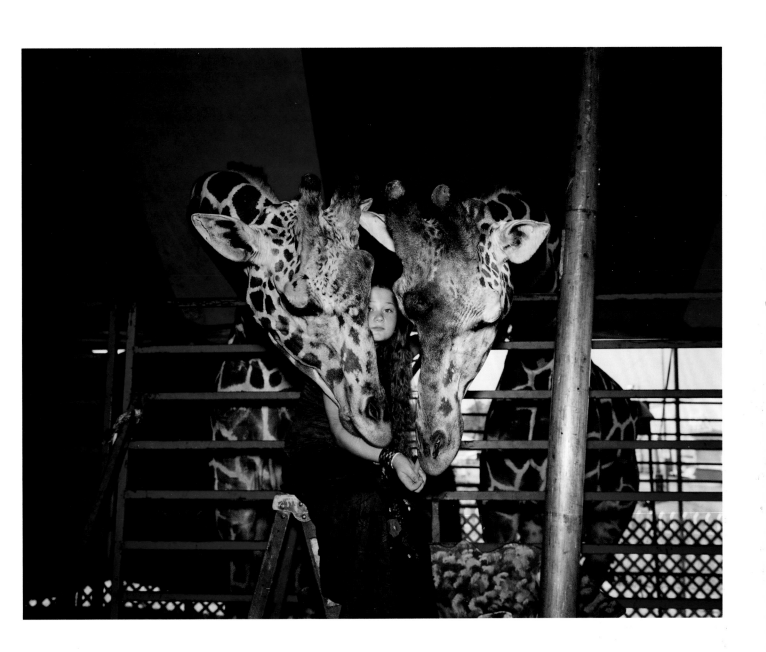

Alfonso Loves Amelia 2008

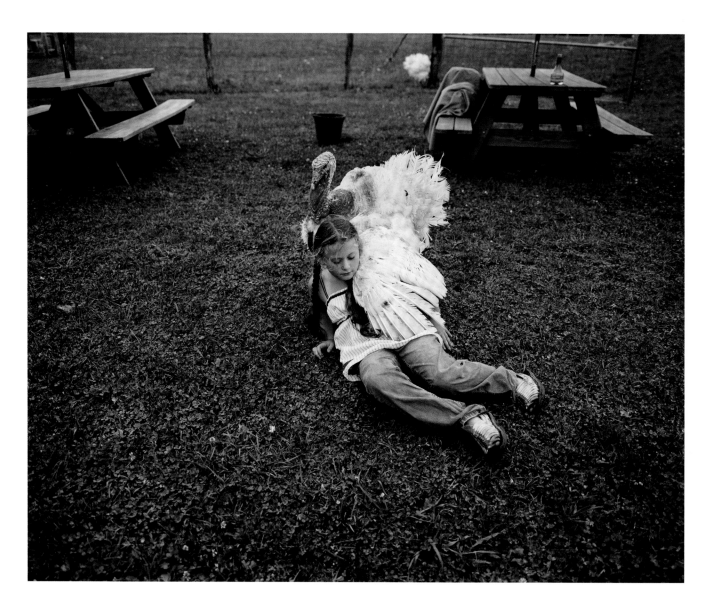

Two Fridas 2008

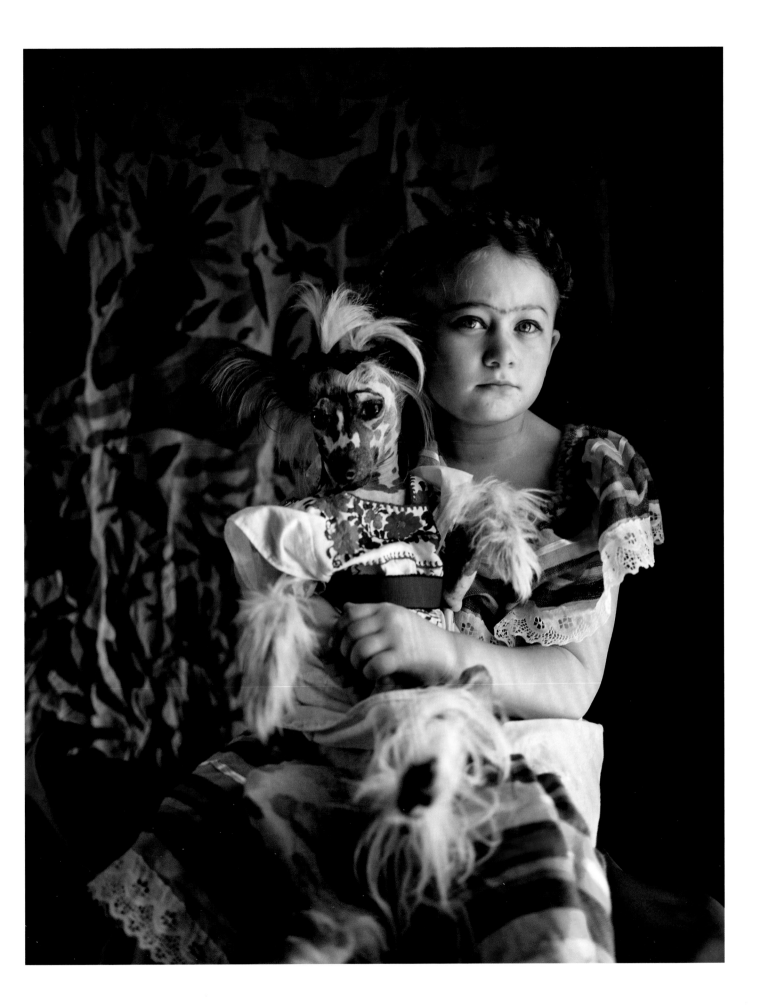

Flying Hannah 2009

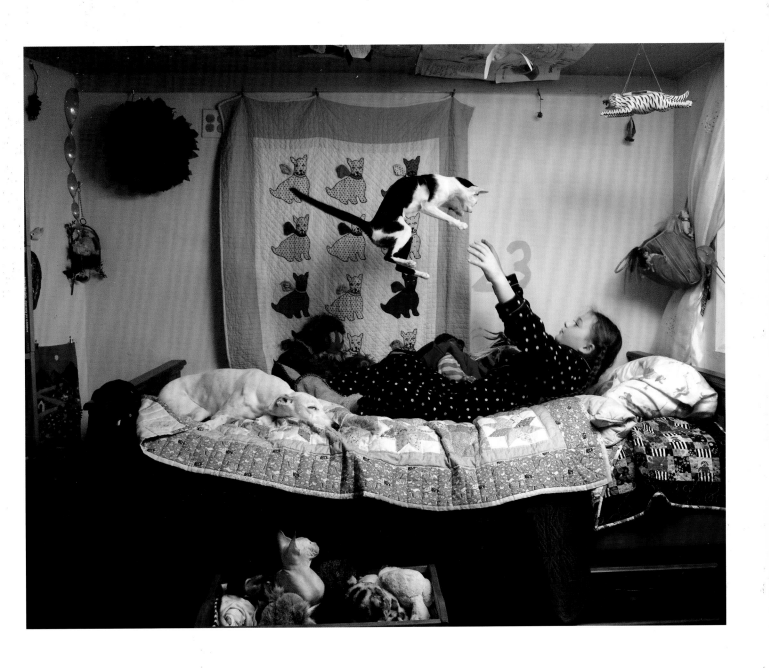

Love Ming 2009

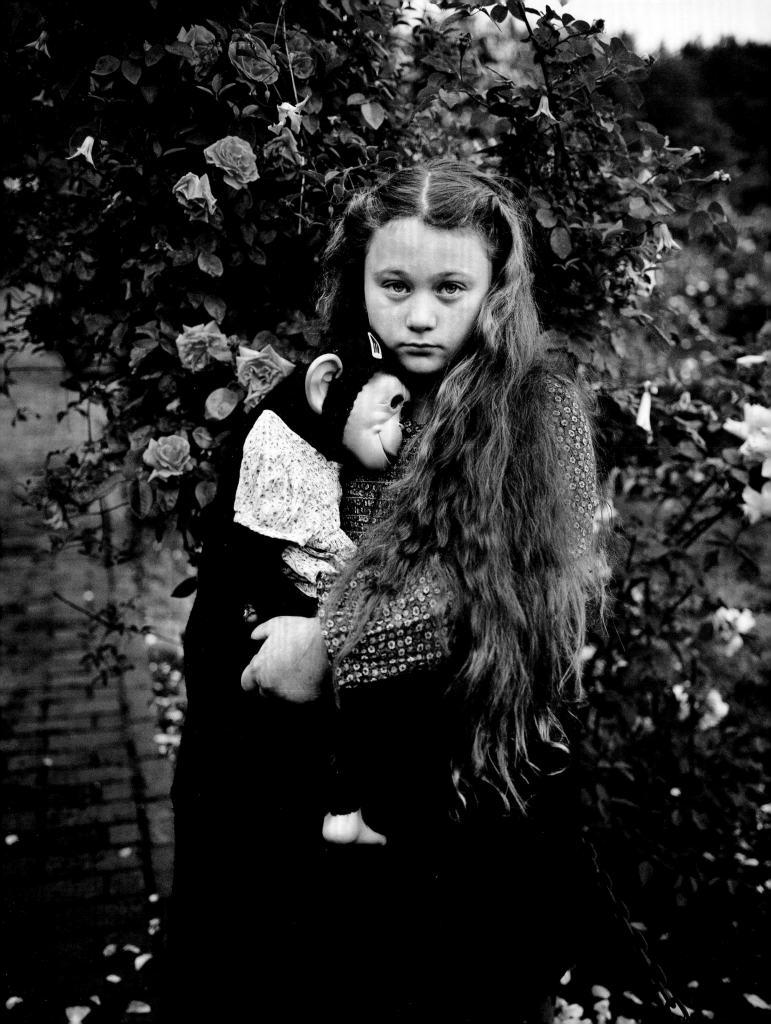

Jacob's Weekly Bath 2009

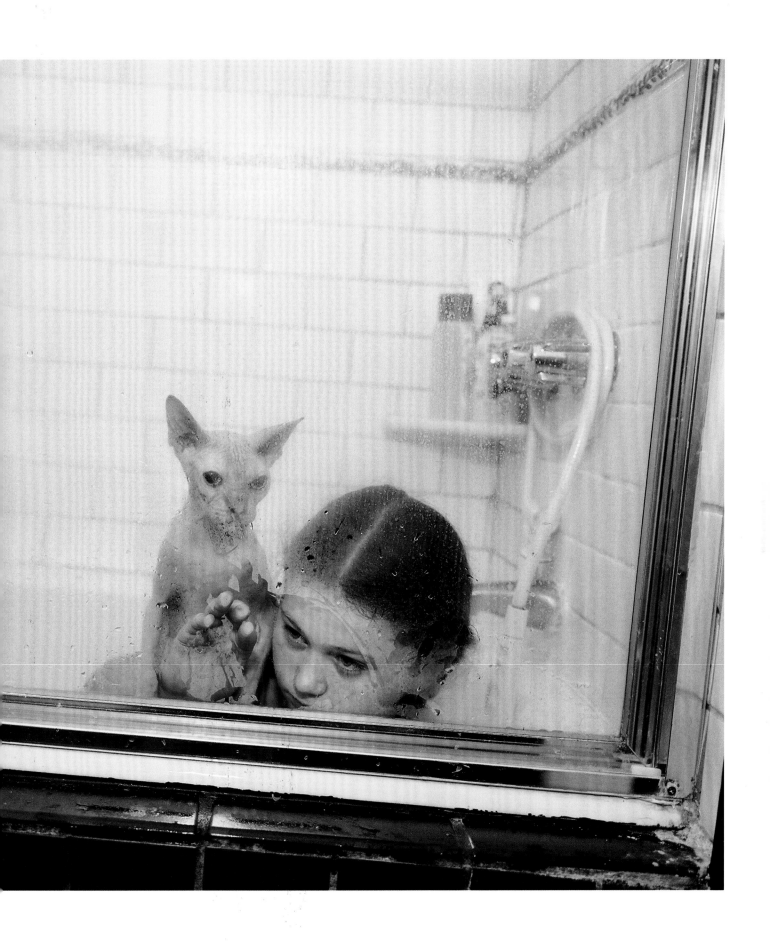

Unicorn 2009

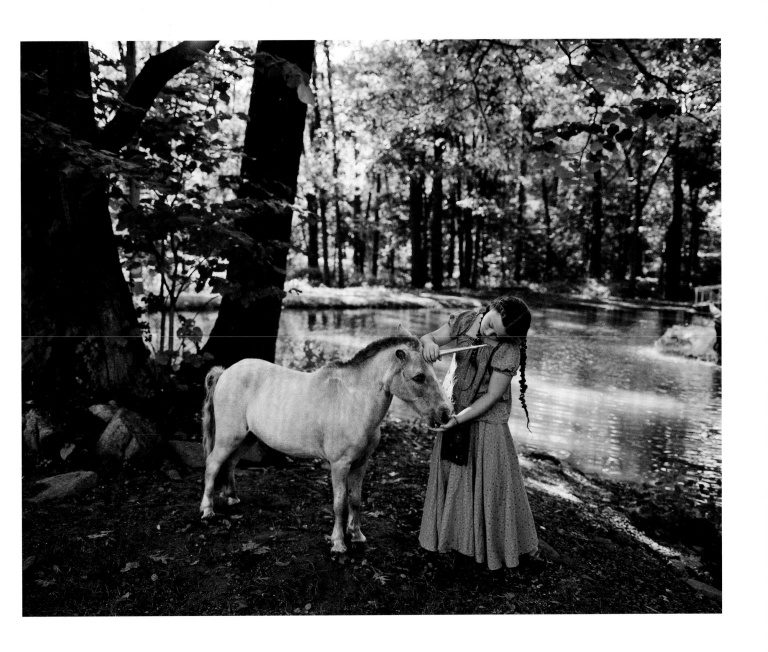

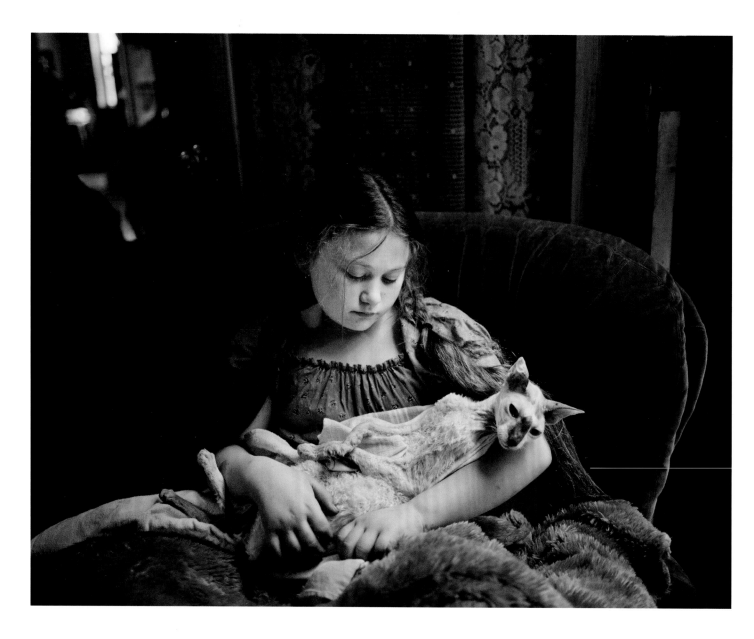

My Nathaniel at the End 2009

Trinity, Rebecca, Jacob, and Amelia 2009

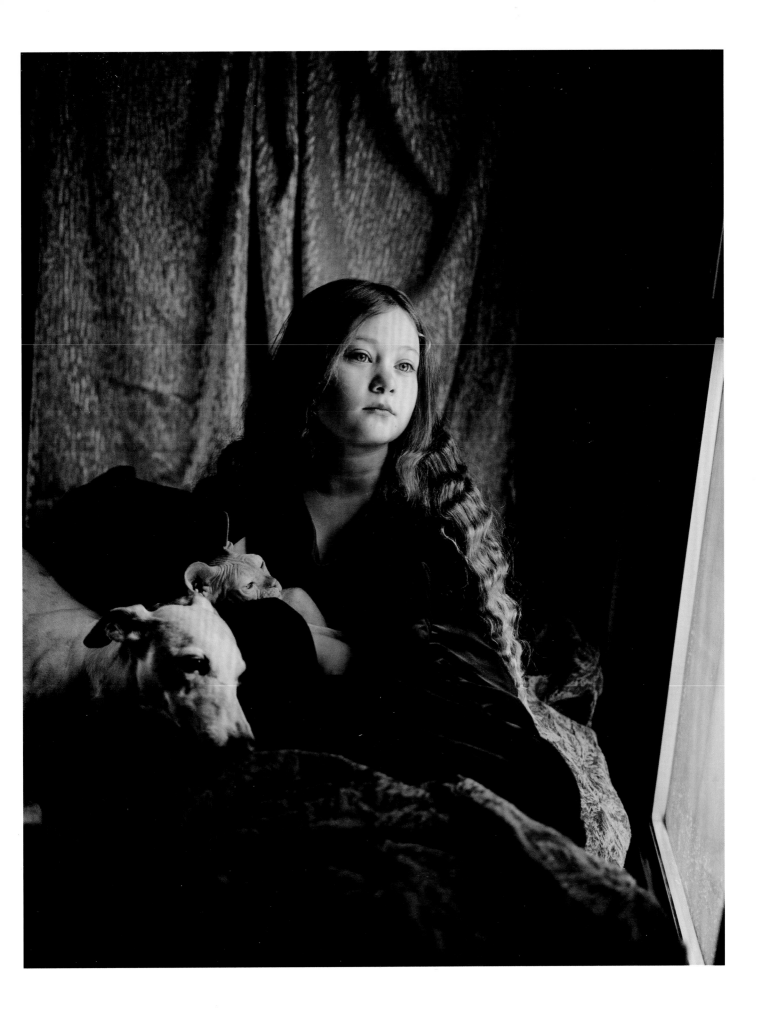

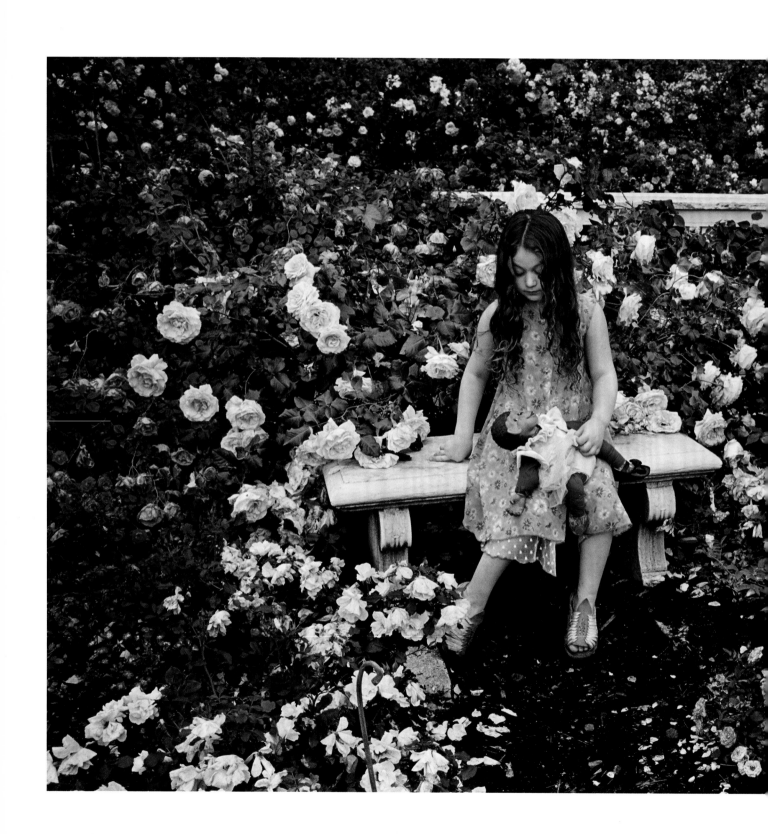

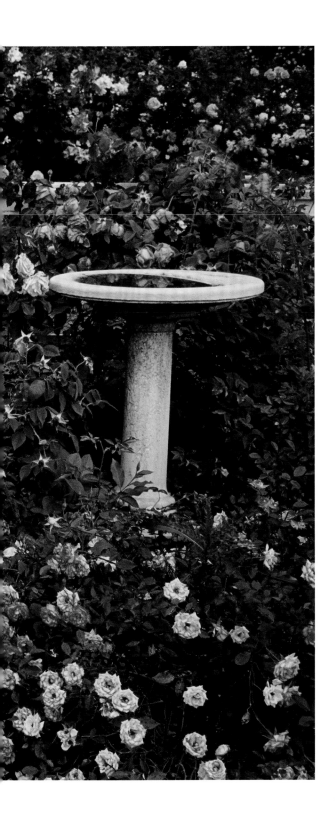

Ruby in the Garden 2009

Majenkir Wildflower (Lacey) and Majenkir My Vixen Aley (Glamour Girl) 2010

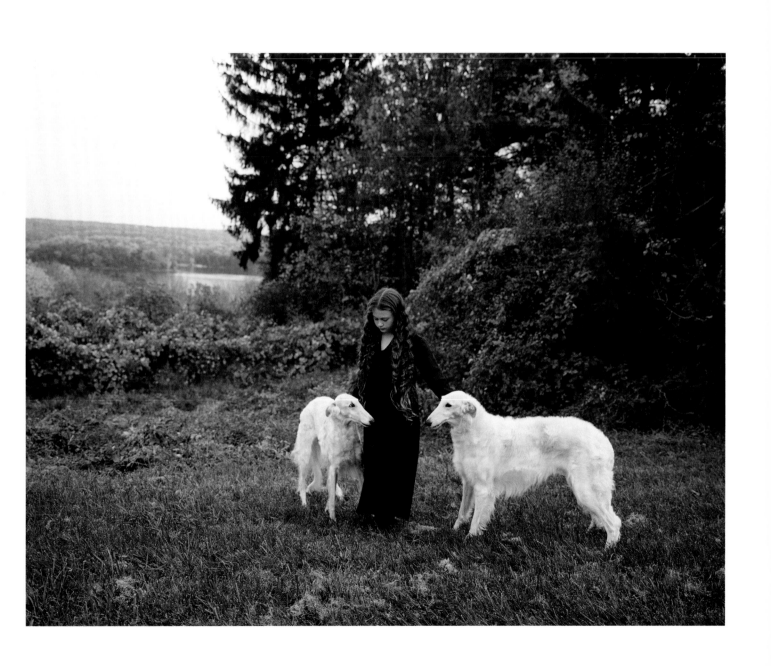

Elijah's Tail 2010

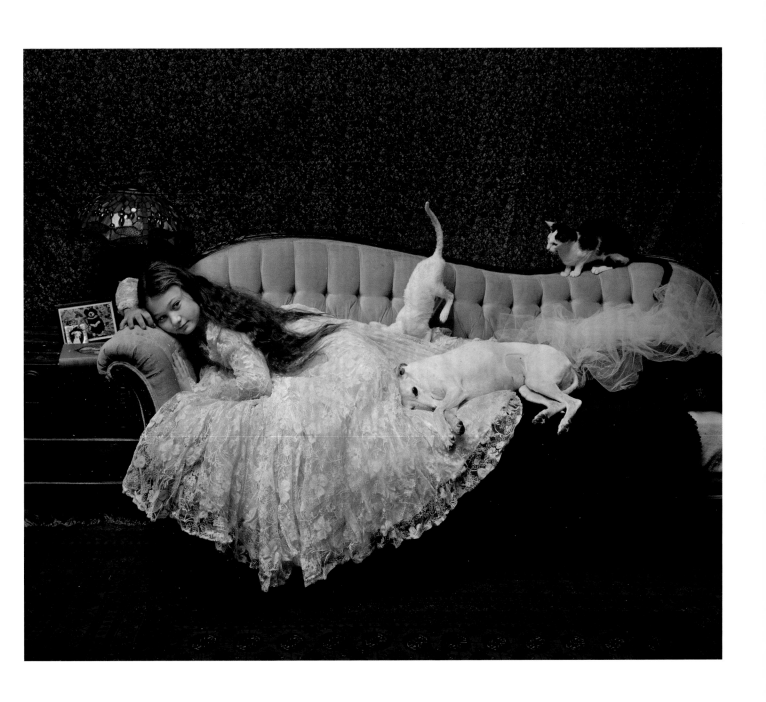

Rooque and Nikki Nila Bean 2010

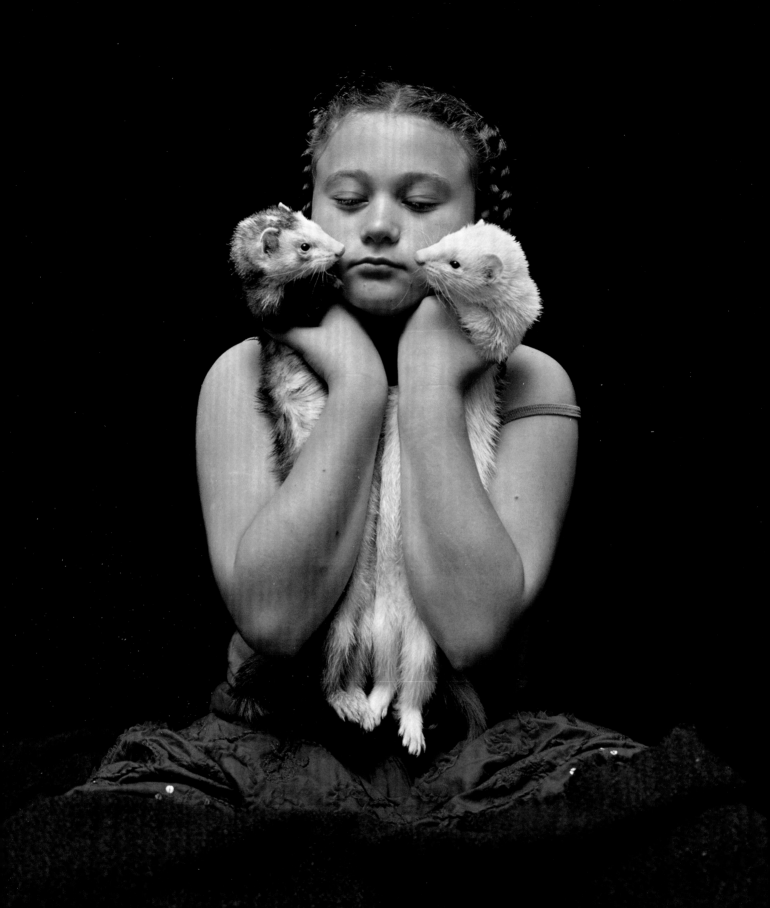

Rascal, Albino Wallaby 2010

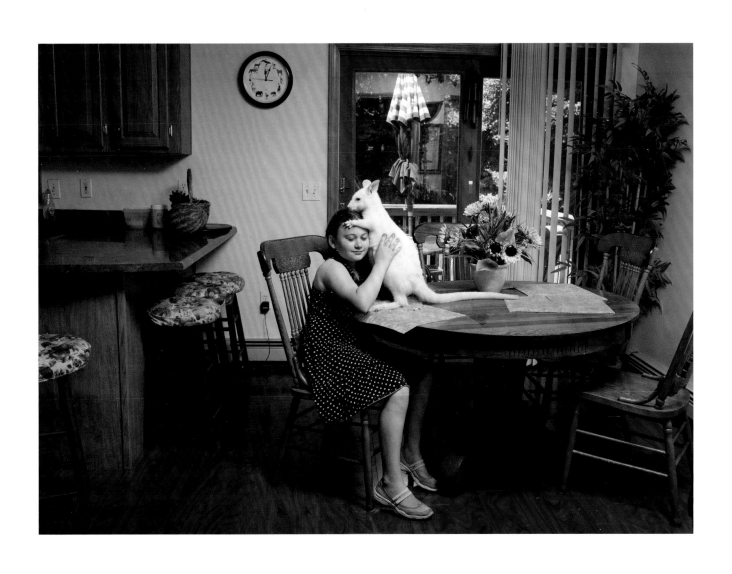

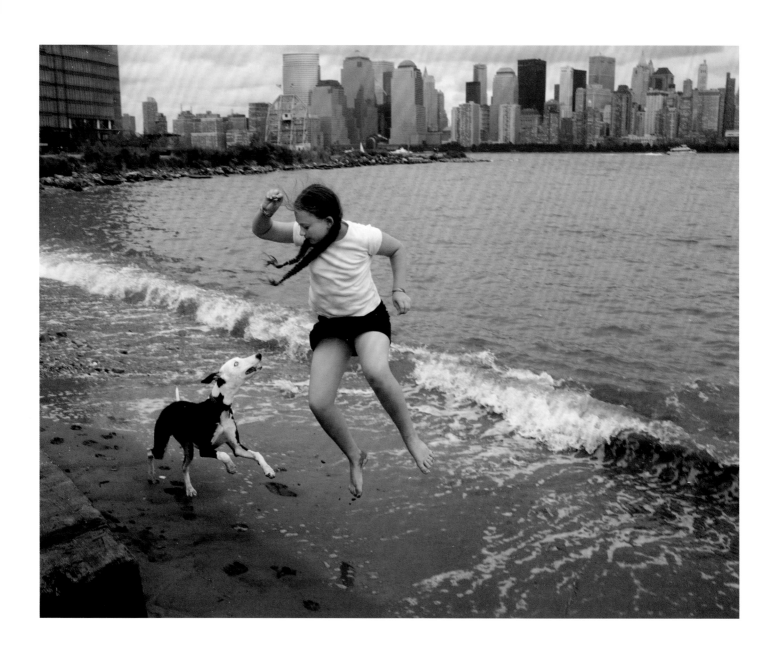

Jumping with Baby Ruby 2010

Elijah 2010

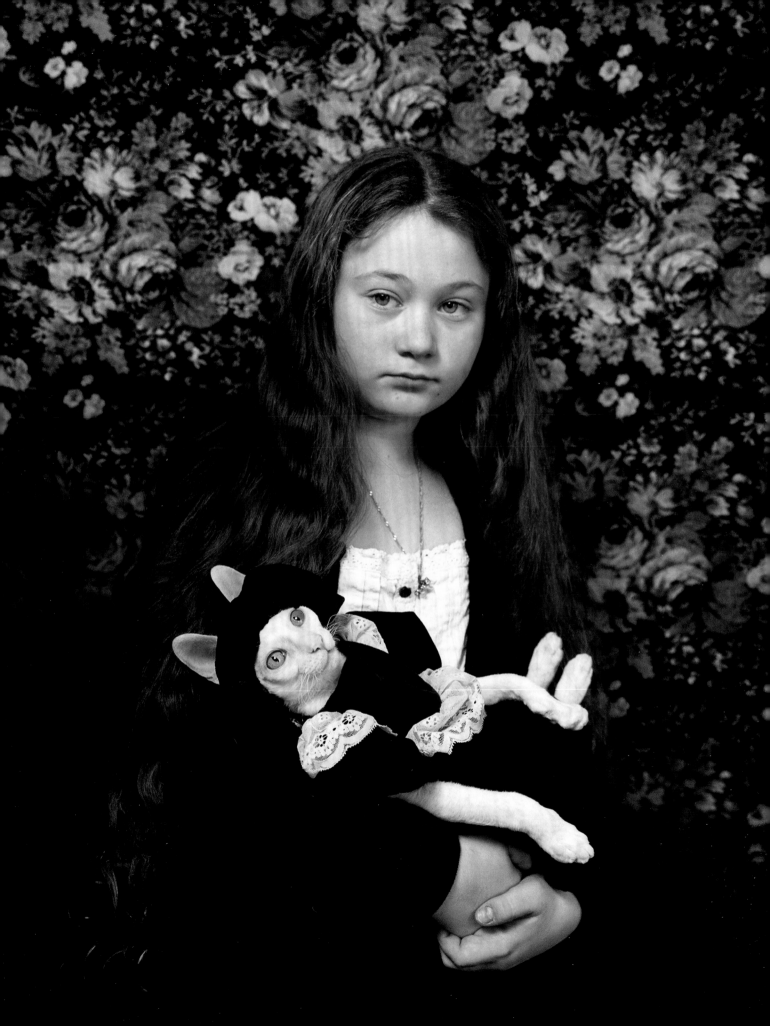

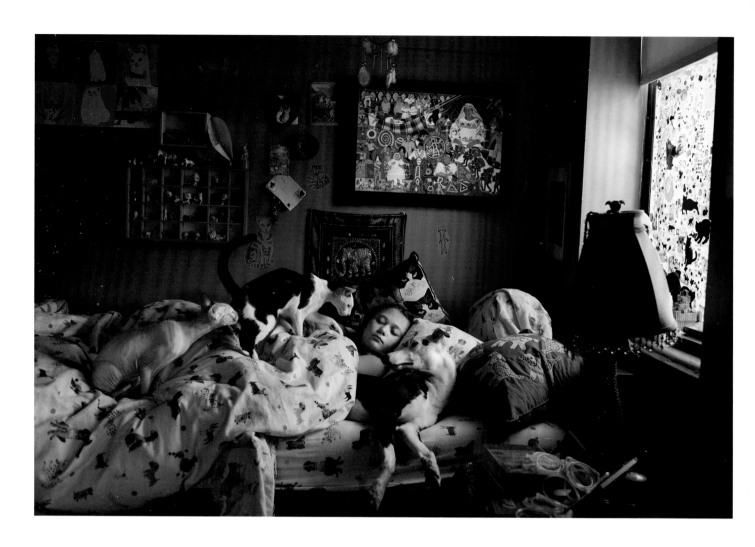

New Year's Morning 2010

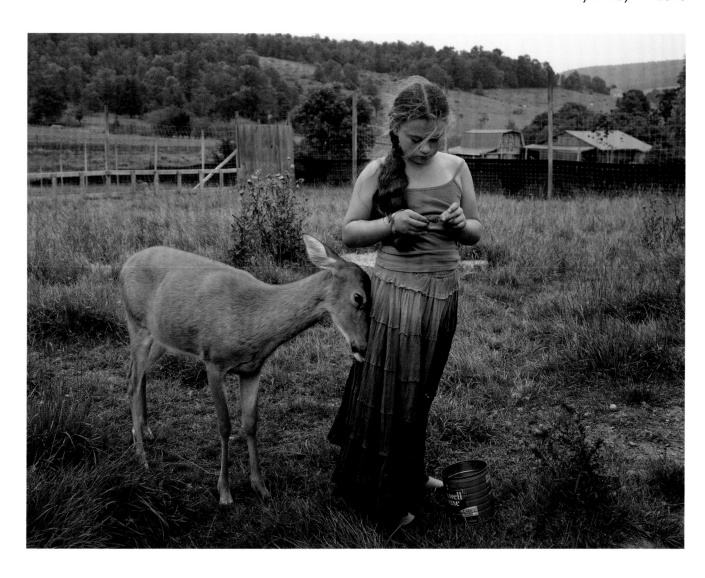

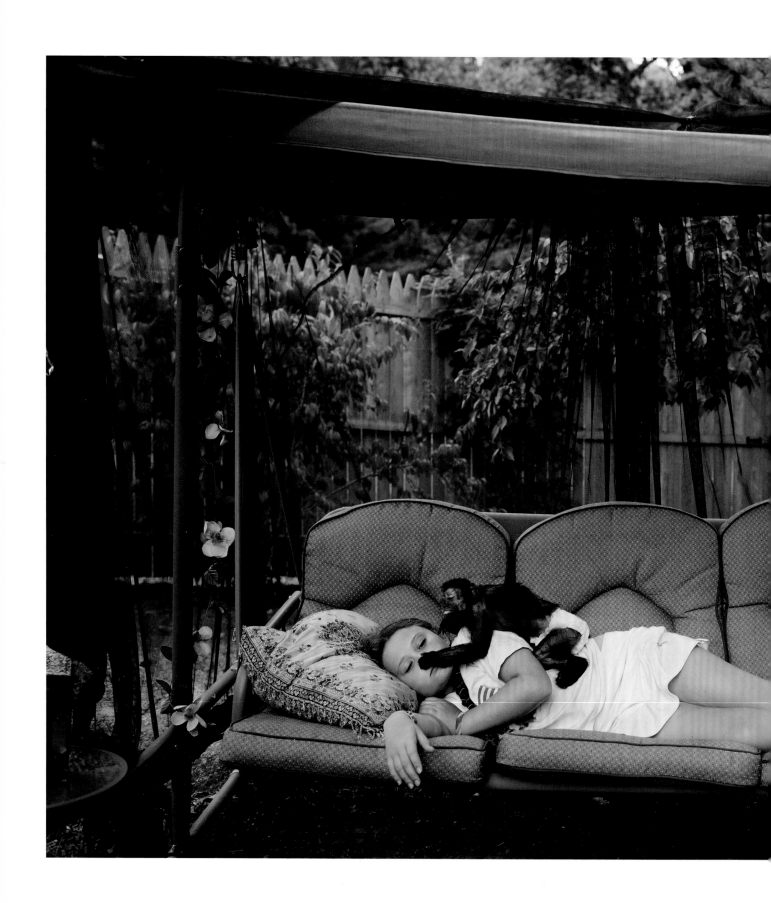

Little Amelia Got Amelia's Nose 2010

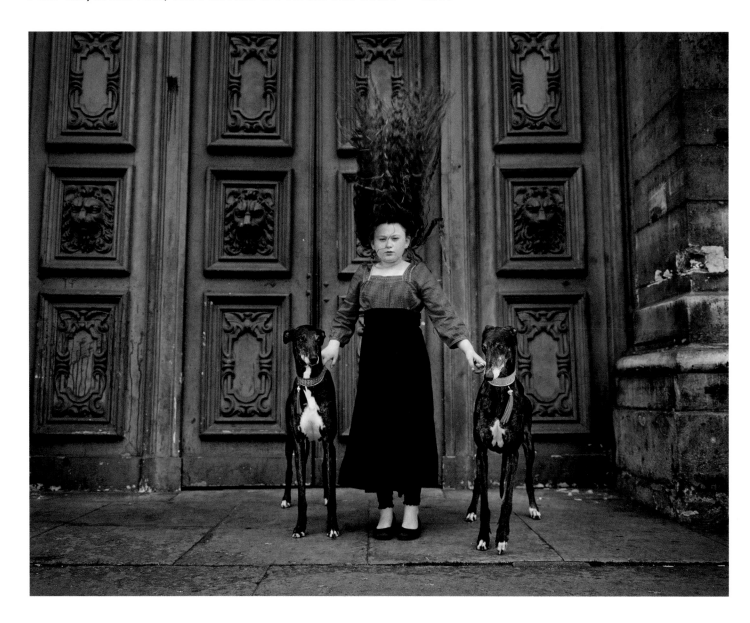

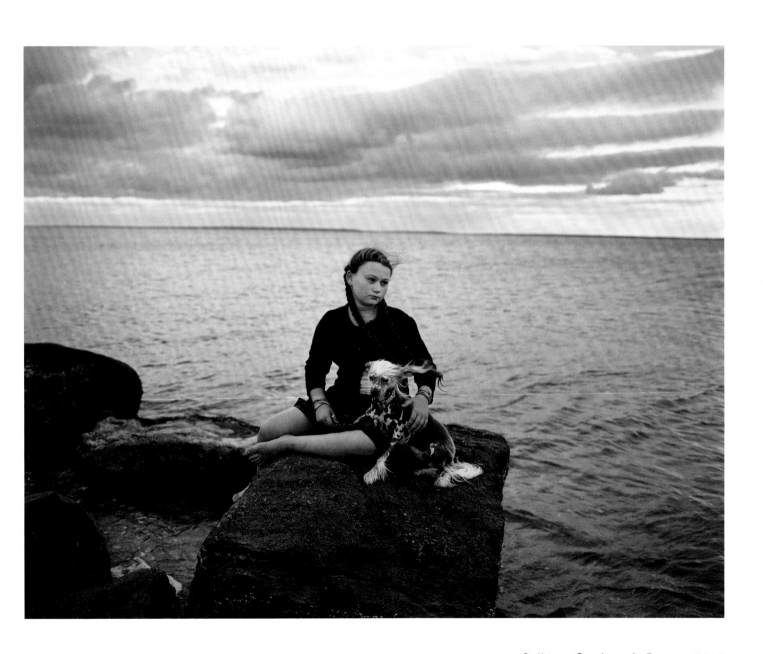

Selkies, Gardener's Bay 2010

Jack, Roo, and Addy, Kangaroo Meet 2011

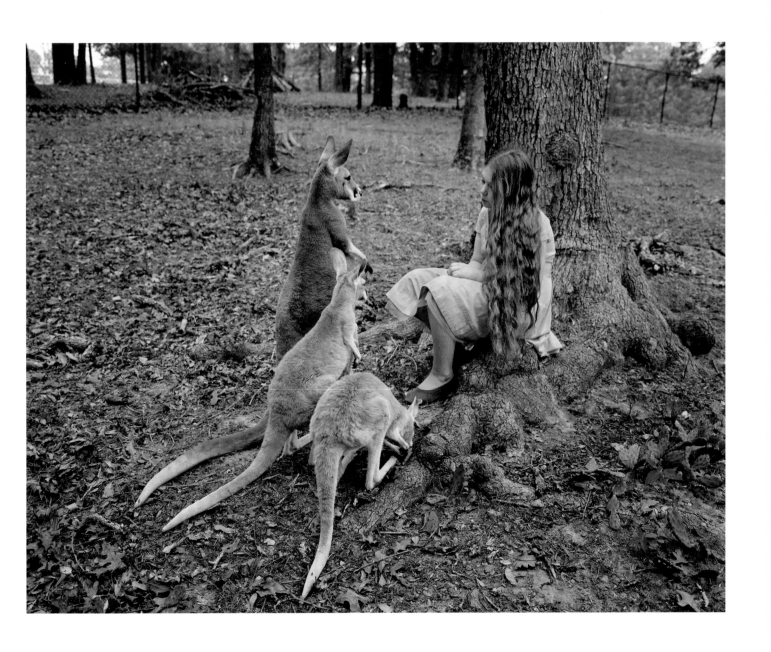

Baby Horned Owls 2011

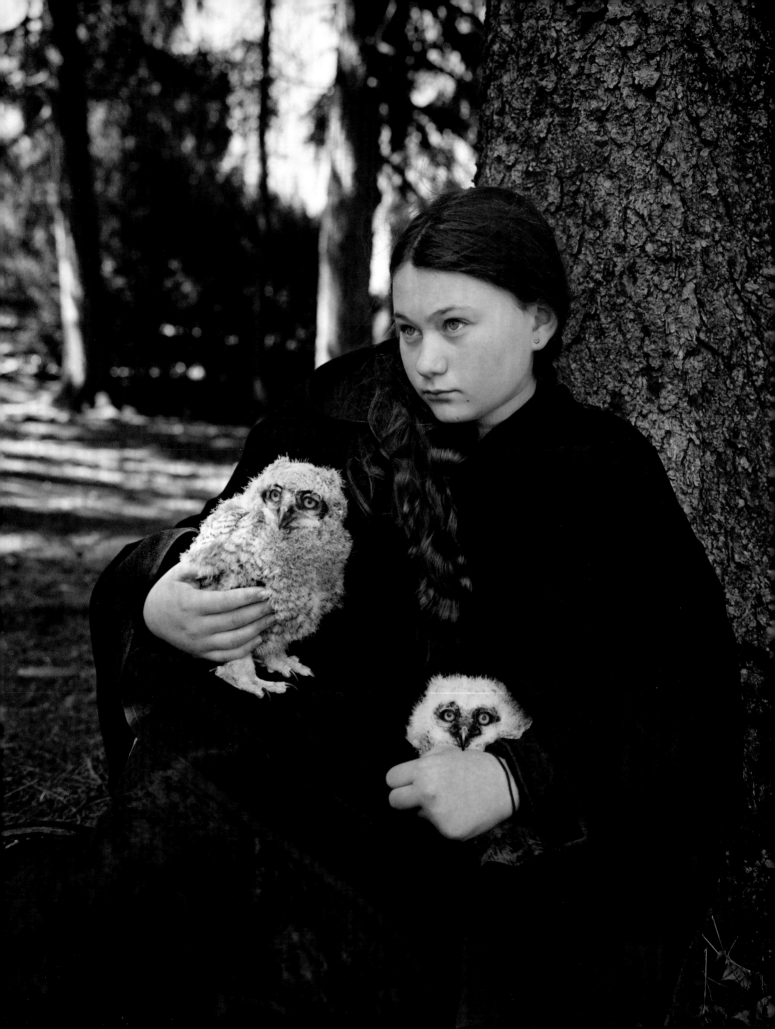

Frank and Louie 2011

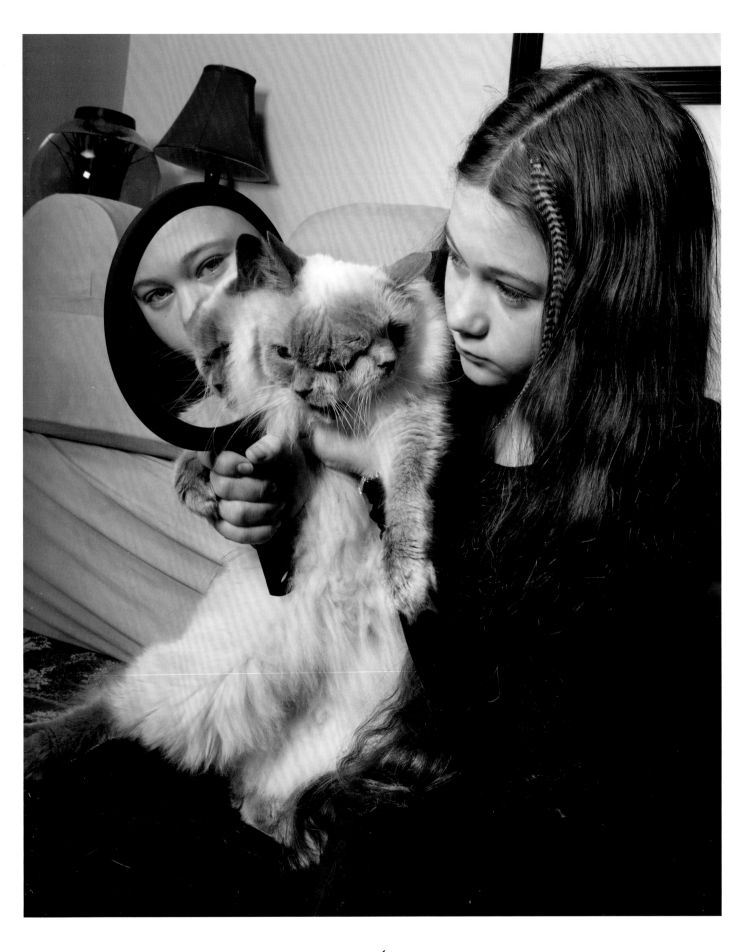

Tigger's Pollinating Tongue 2011

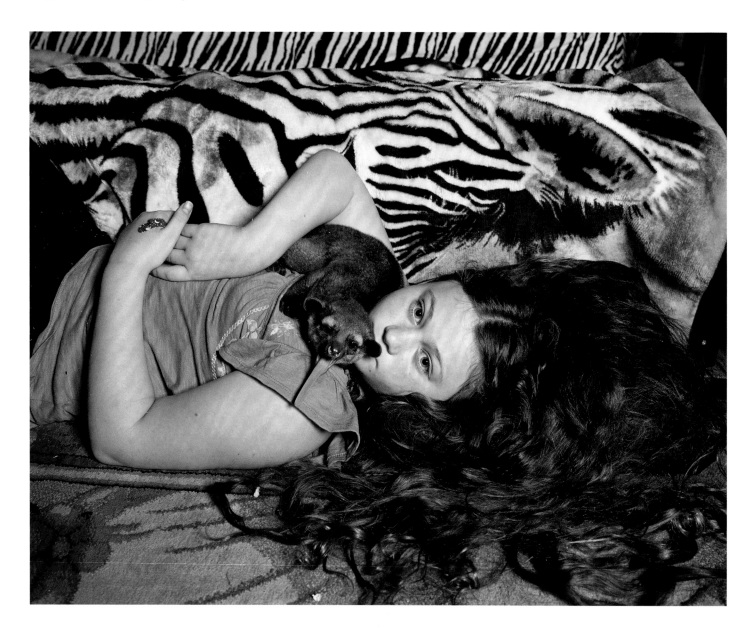

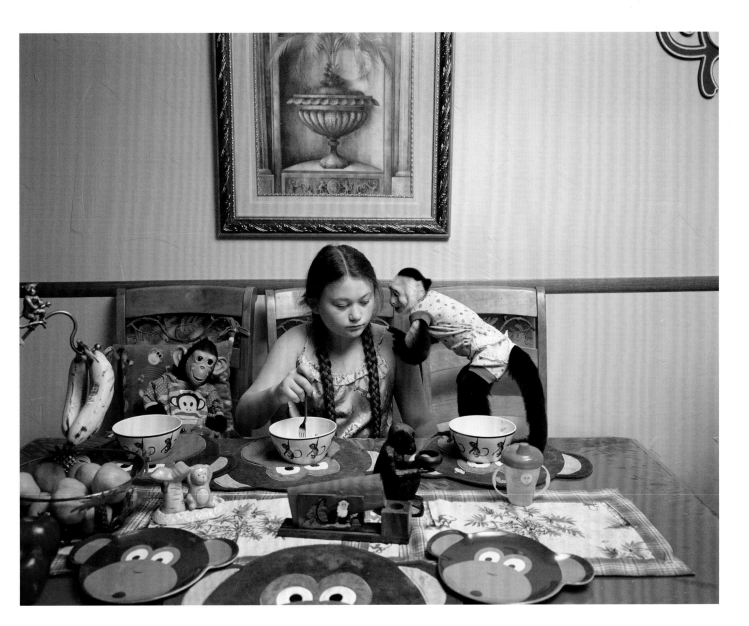

Breakfast Talk with Rosie 2011

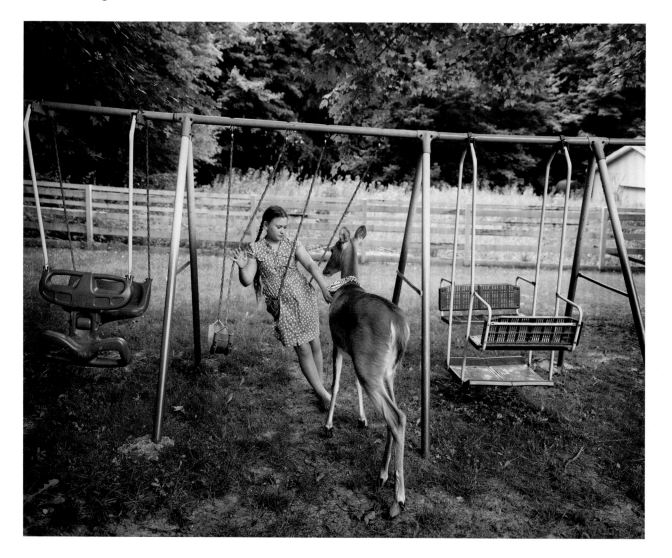

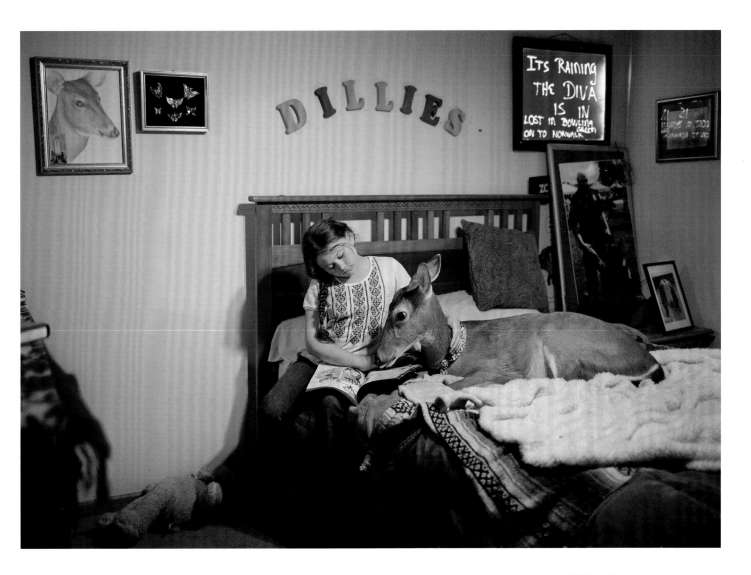

Dillie's Bedroom 2009

Lorenzo 2011

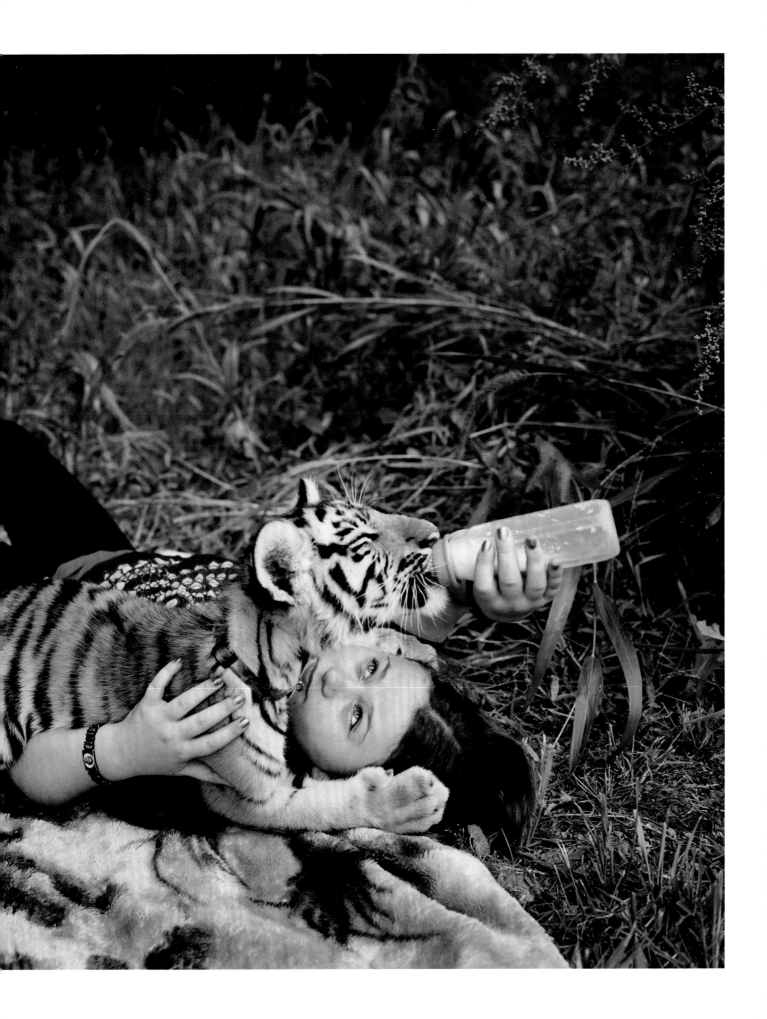

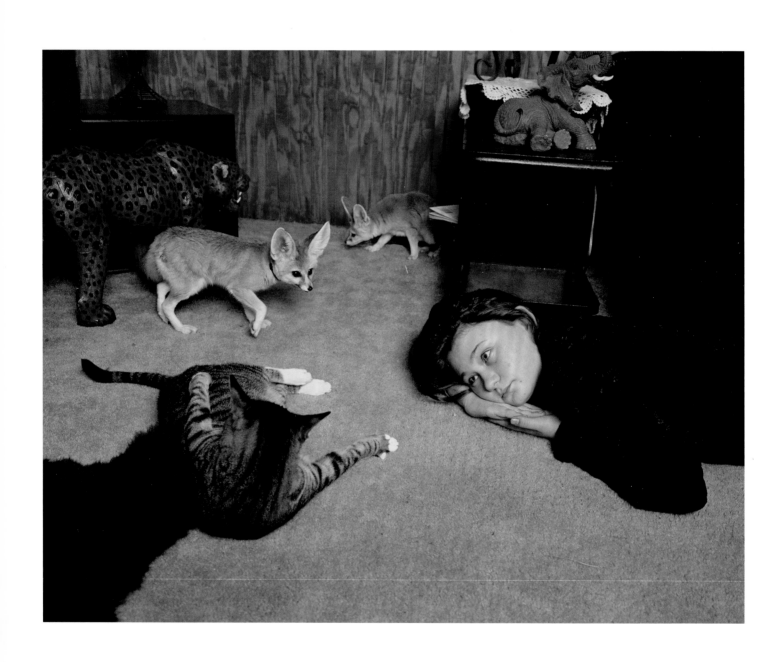

96 /

Sparky, Gilbert, and Patty 2011

Pancho in the Window 2011

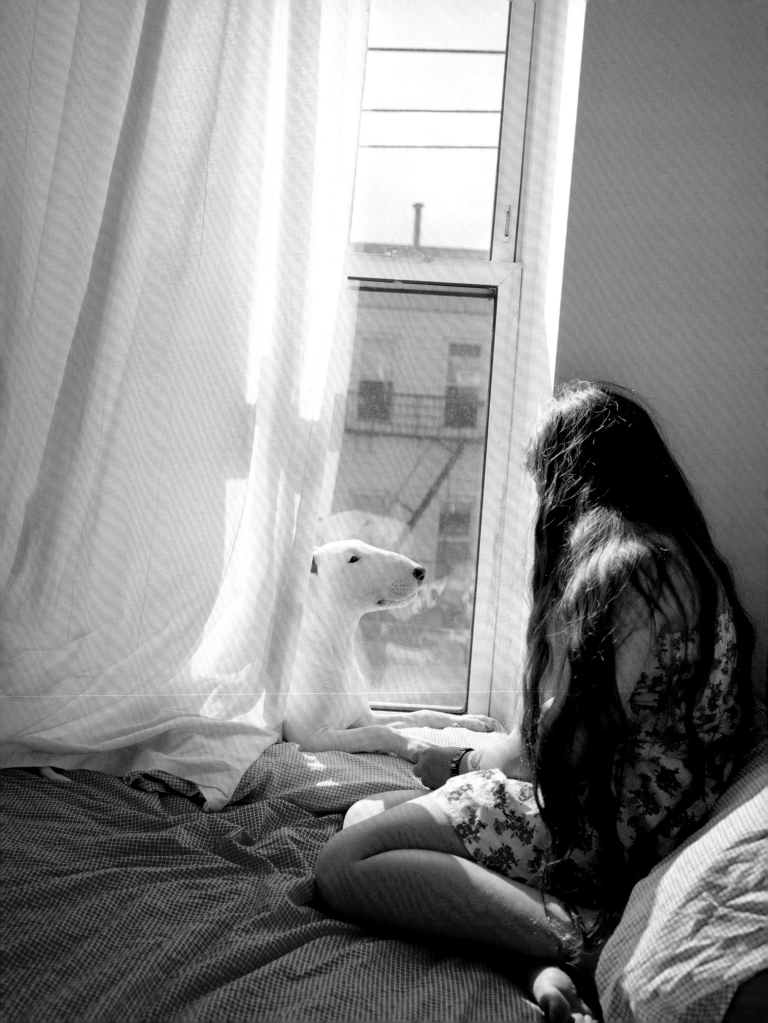

Madee's Test 2011

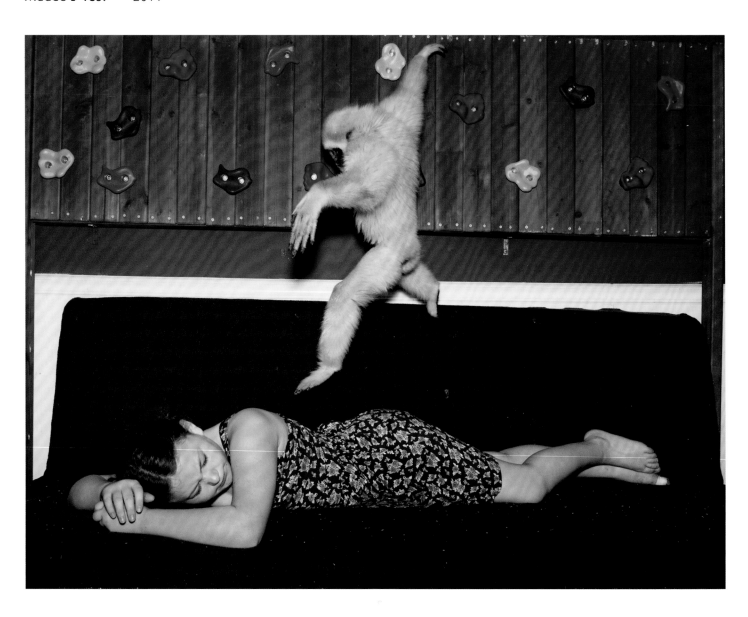

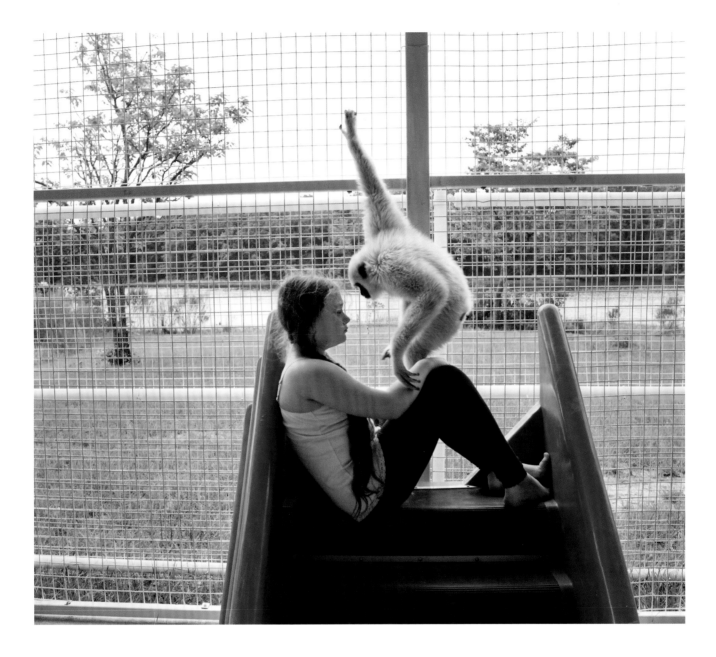

Madee Making Friends Again 2011

Rosie Likes Breath 2011

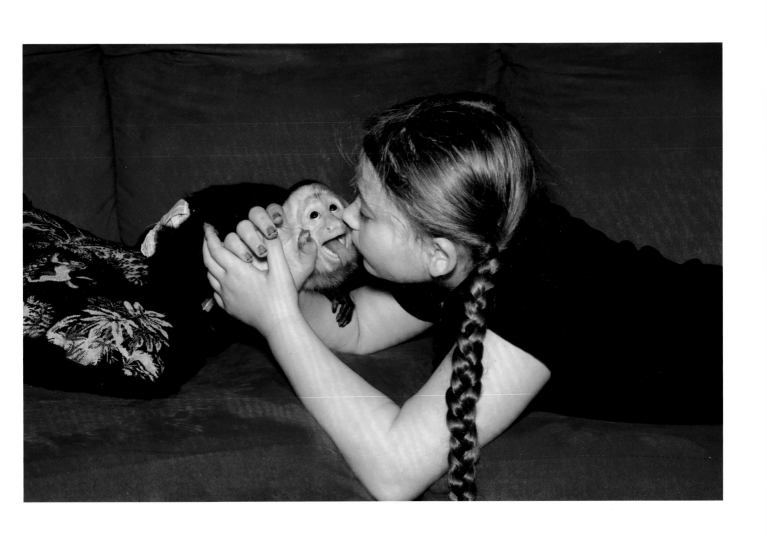

Samantha in the Cabinet 2011

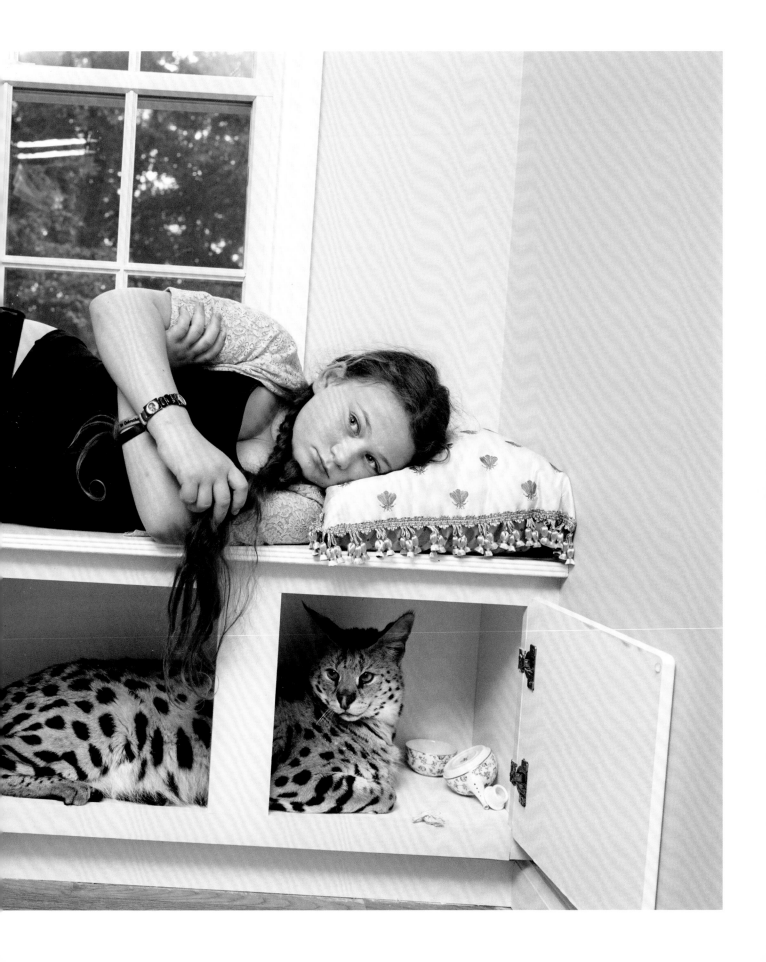

Lola Does Not Like Fake Fruit 2012

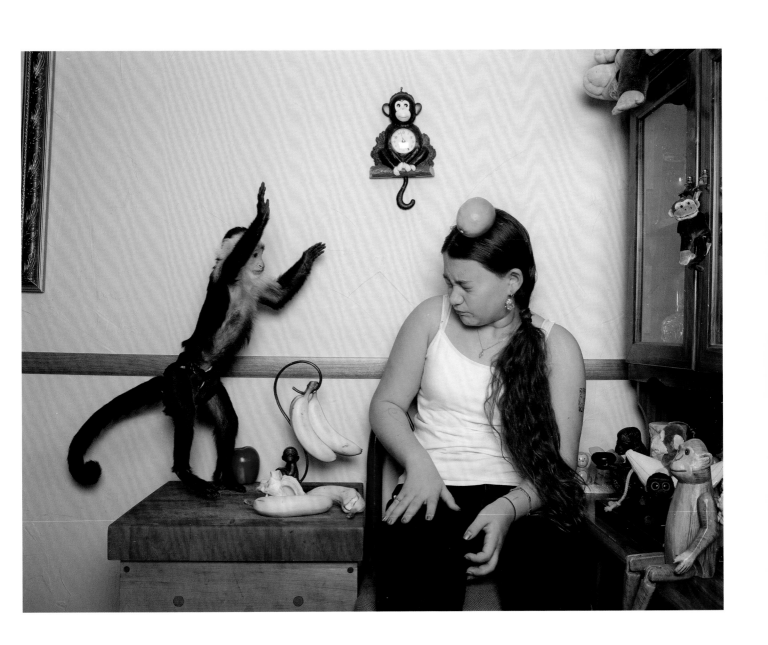

Tash 2012

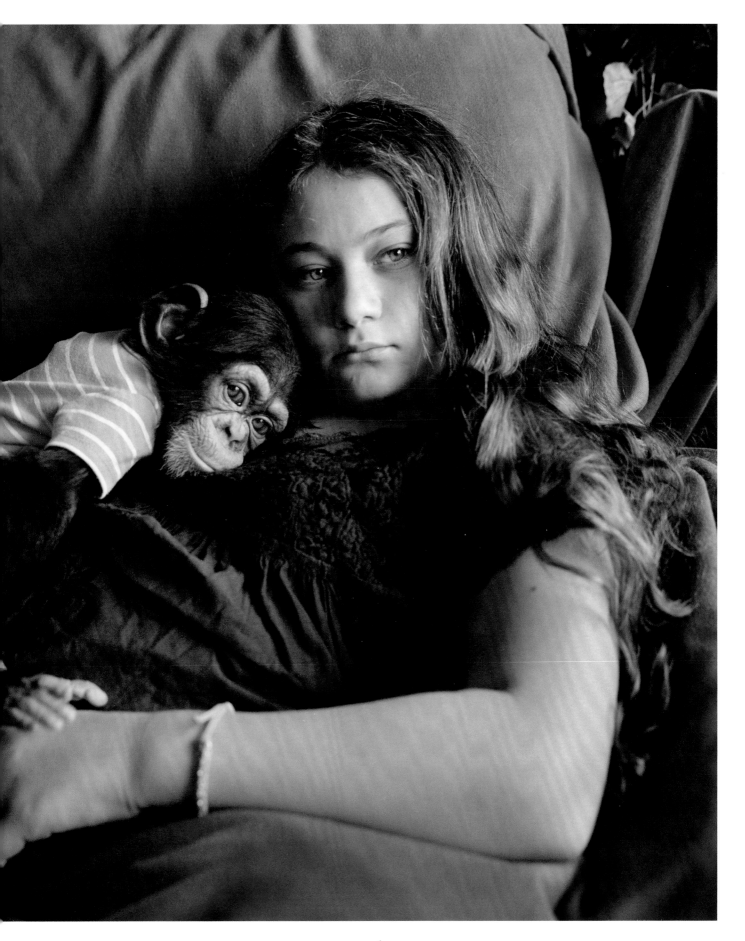

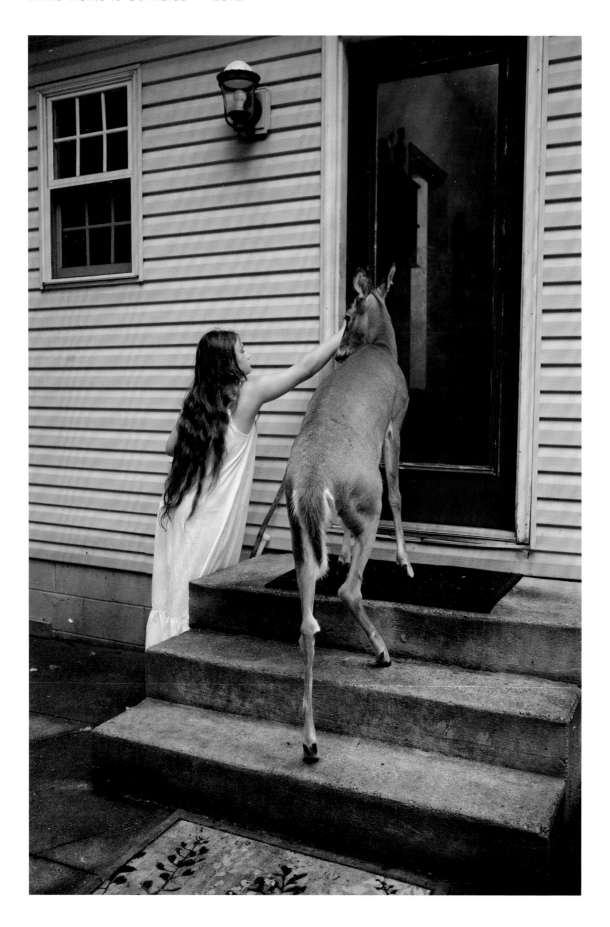

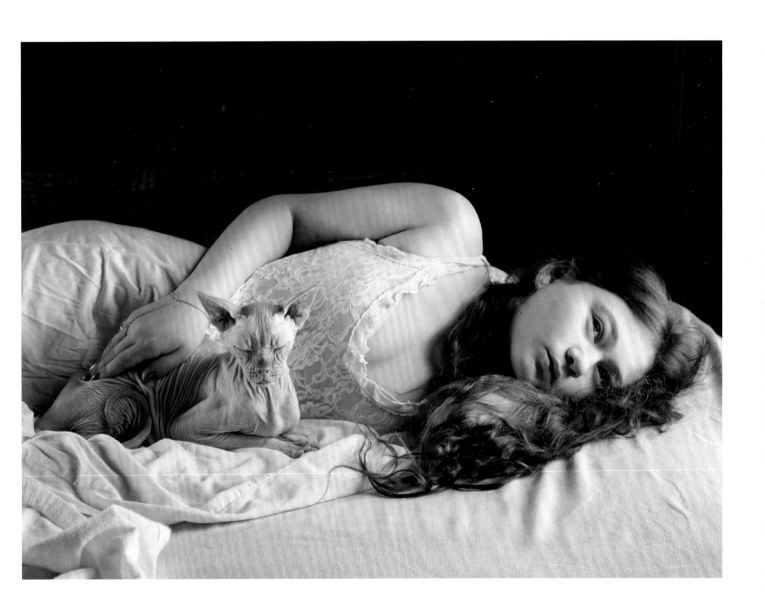

Tower II (Goodbye, Jacob) 2013

Thunderfoot Still Loves Amelia 2012

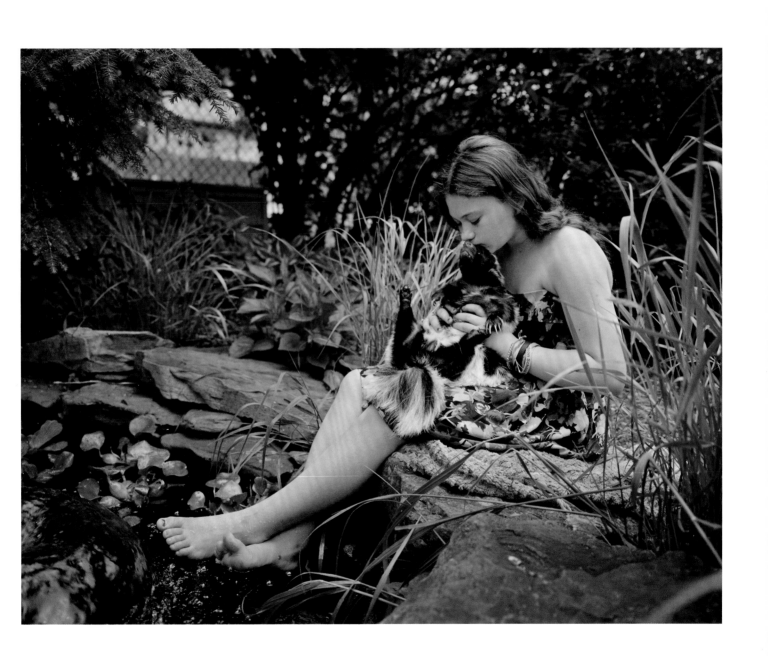

Raz, Zebra 2012

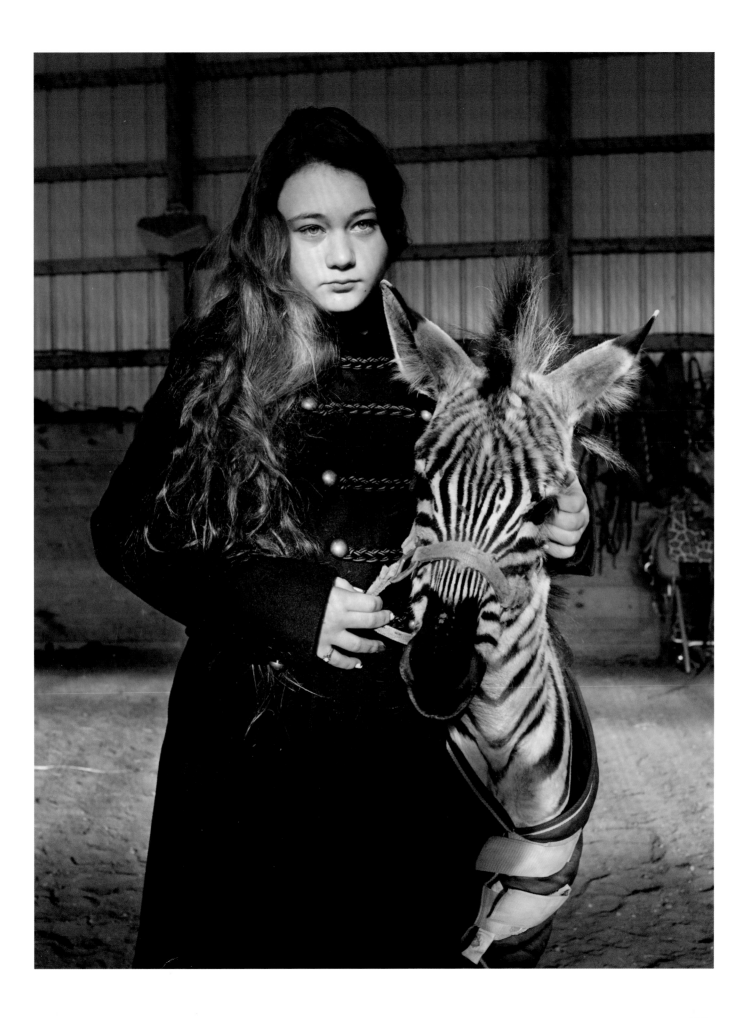

Beautiful Snow Pied Erway 2013

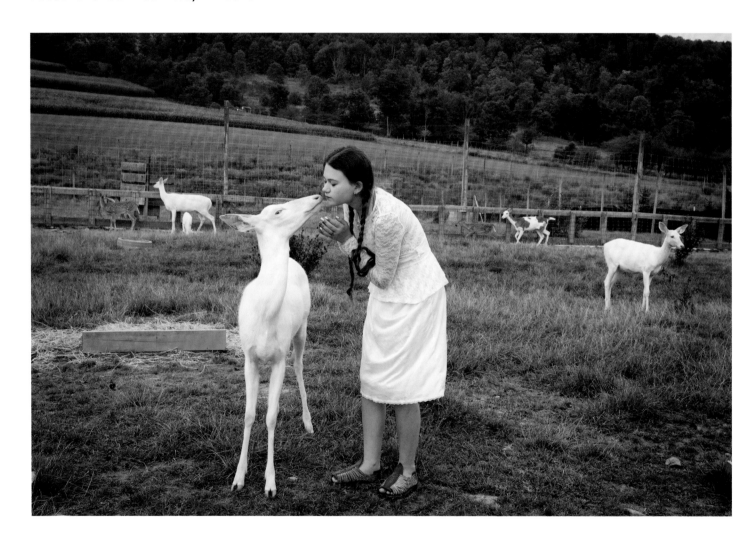

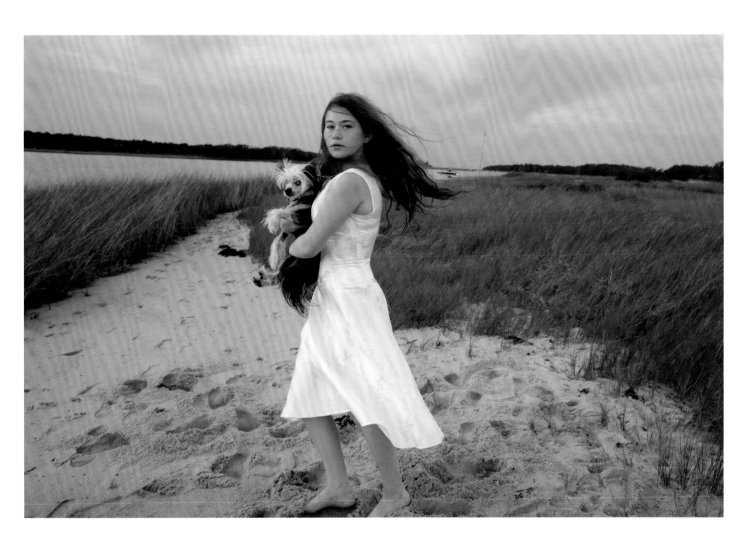

Indie and Amelia Twirl on Grandpa's Beach,
Gerard Drive, Springs, Easthampton 2013

All Together for the Last Time; Nora, Hannah, Ruby, Jacob, and Sammy
(Homage to Mickalene Thomas) 2013

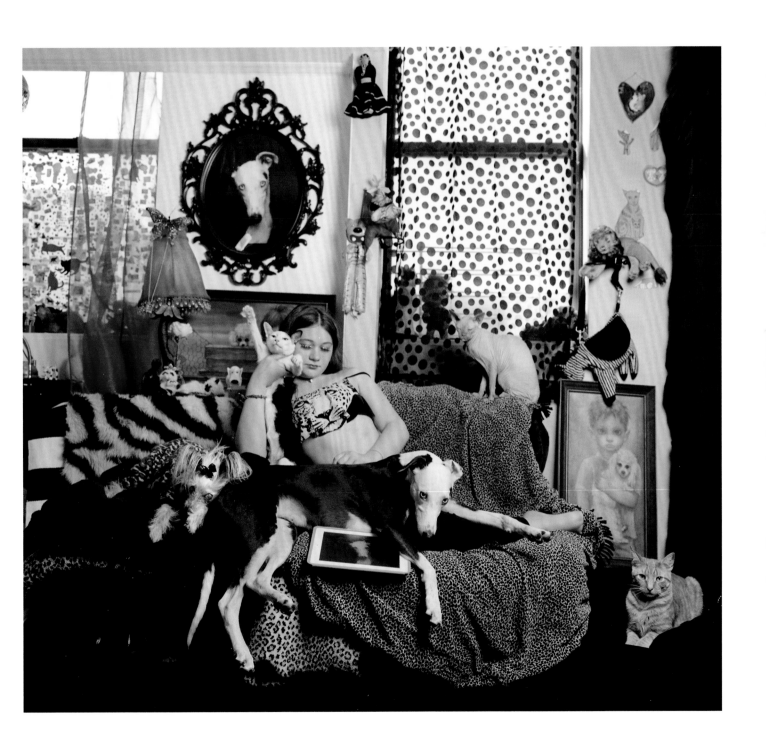

Poppy Nagel Is a Kind Host 2013

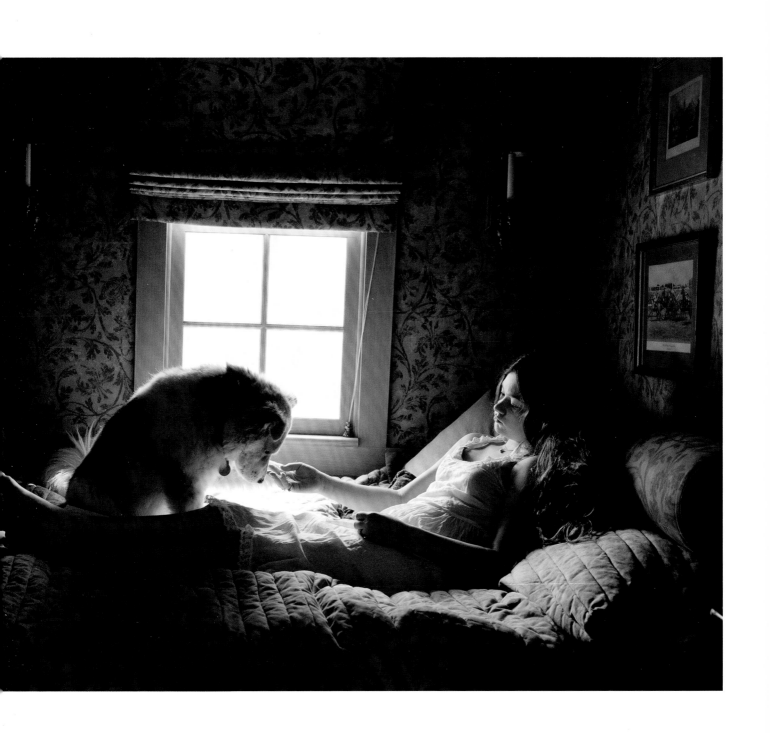

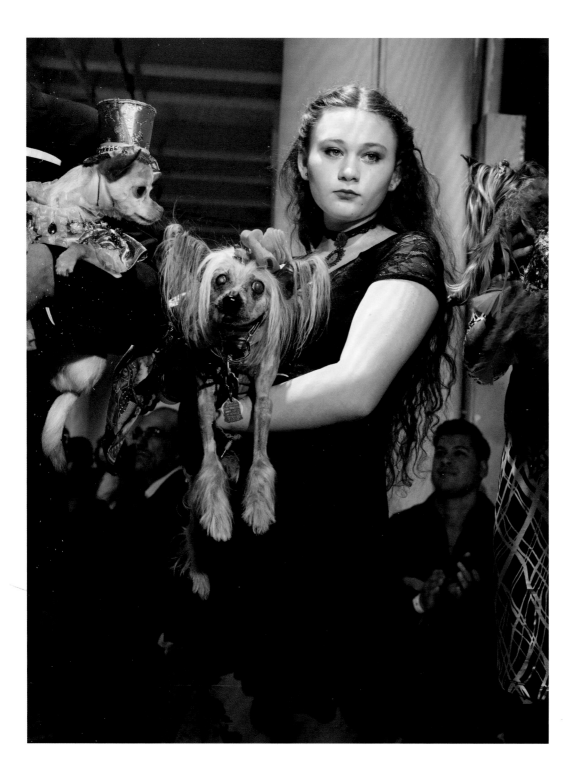

Nora and Amelia, Runway Finale at Brooklyn Fashion Week,
Anthony Rubio's Virgin of Guadalupe Gown 2013

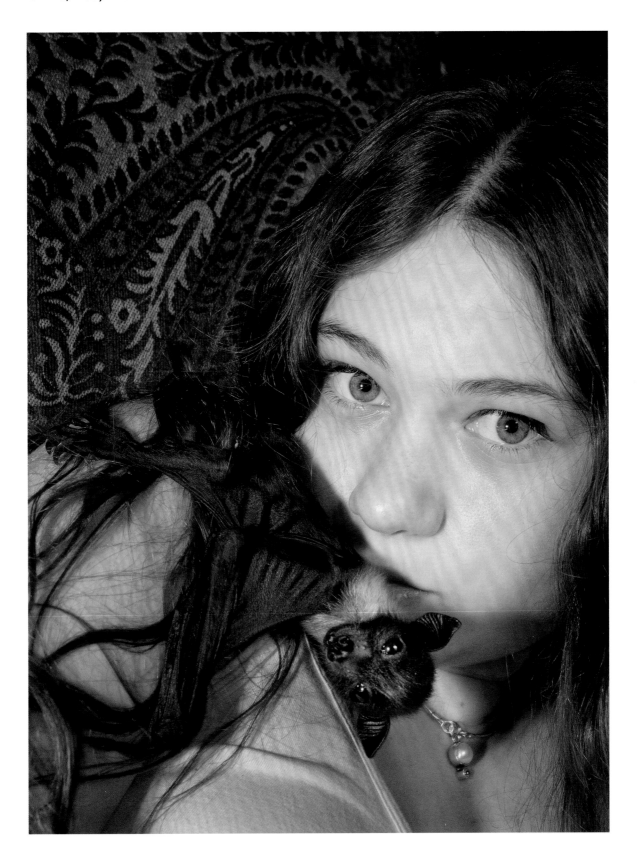

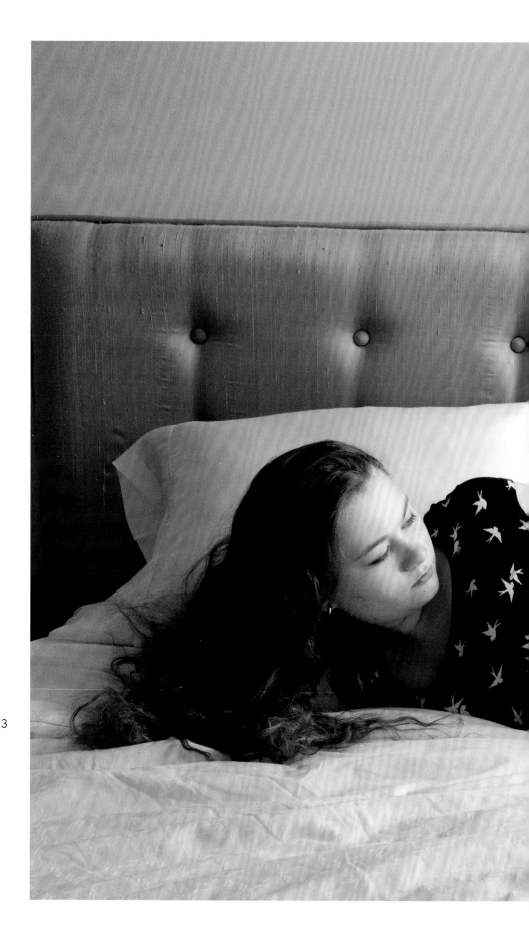

Violet Cockatoo　　2013

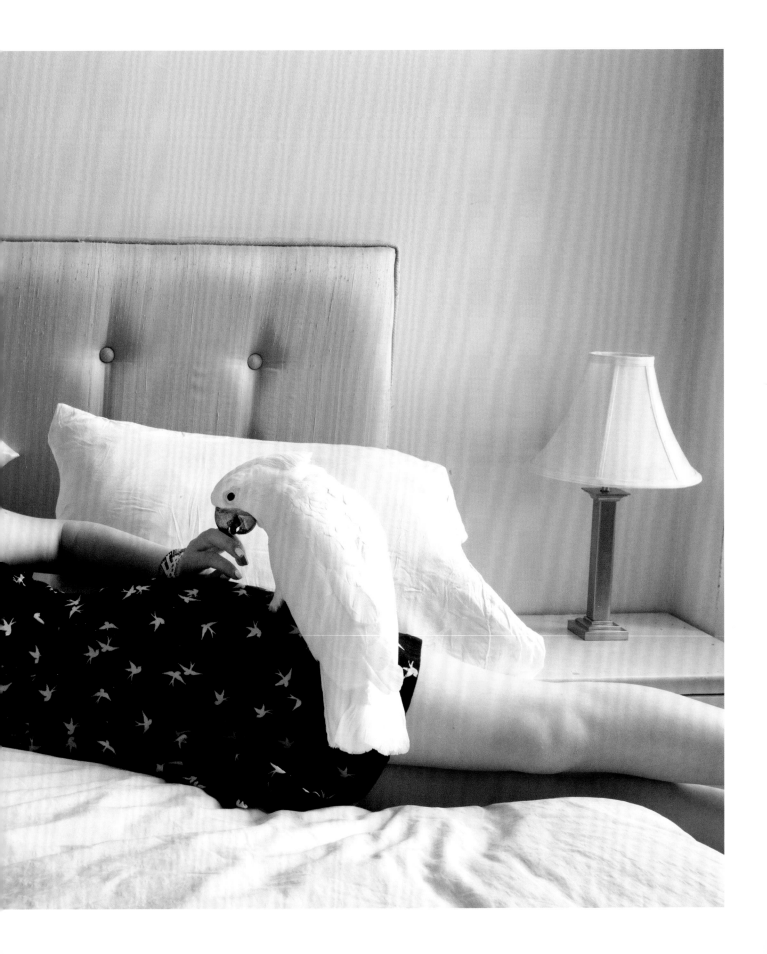

Tash Love 2013

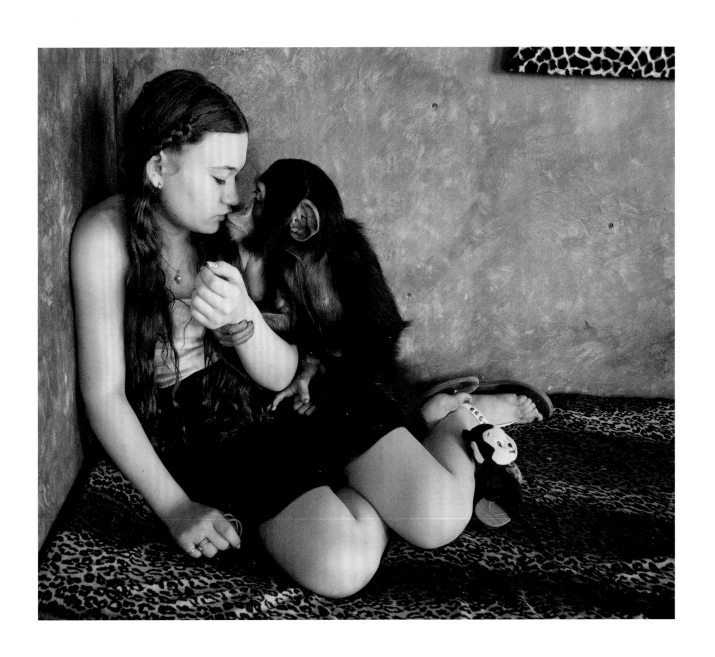

Doug, Baby Capuchin 2013

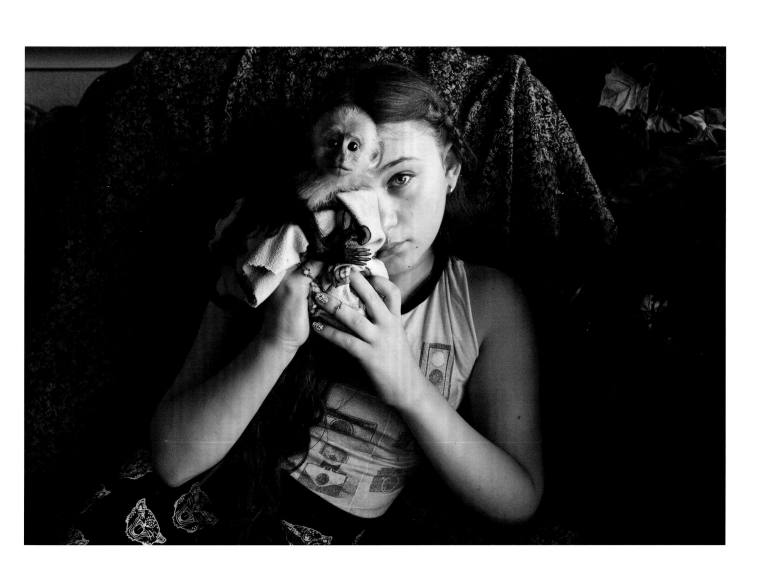

ROBIN
&
THE ANIMALS

BY DONNA GUSTAFSON

There is an uncanny edge to these gentle

encounters between a young girl and a variety of exotic visitors (or are they more like emissaries?) to the human world. Elephants, gibbons, giraffes, kangaroos, kinkajous, lemurs, and wallabies are not species that fit easily into everyday life in twenty-first-century America, but here they are in our neighbors' backyards, bedrooms, kitchens, and dining rooms.

For most of us animals are no longer at the center of our world, but they live large in our collective imagination. Reimagined as cuddly toys, cartoons, heroes and heroines, villains and victims, they fill popular culture as their real counterparts are pushed to the brink of extinction. Does the disquieting effect of these photographs of Amelia and the animals come from our knowledge that the natural world has been marginalized nearly to the point of irrelevance, or is it the articulation of a liminal and emotionally charged space between species—a connection that we prefer to ignore so that we can continue to see animals as lesser beings—that unnerves us? Or is it the palpable sense of loss? These photographs whisper of lost intimacies and half-remembered myths. Stories of animal power and the threats that women like Circe posed to heroes like Odysseus lie just beneath the surface. There is also a hint of reproach. Are these animals here in the human world because they've been rescued from some awful fate? Are they content in this alien world? Who is this girl-child, so quiet and attentive to their emotional needs?

One of the most pressing issues of our age is the relationship between humanity and the rest of the planet. As more and more species fall prey to extinction, and global climate change threatens not simply animal habitats but also large urban centers on the banks of rivers and on the coasts of the world's ocean, we're forced to reassess our connection to the biosphere. Contemporary artists like Mark Dion and others have mined this vein, deconstructing our definitions of nature and reminding us that knowledge is subject to bias and often rooted in preconceptions that must shift over time. Our understanding today of the distinction between wild and tame, for example, has roots in Judeo-Christian beliefs about man's dominion over the animal world. Drawing on the biblical story of the fall of man, Enlightenment thinkers asserted that there were two conditions for animal

nature: wild and tame. These two states were the consequence of animal rebellion against or acceptance of humanity's God-given dominion over the Earth. Further, it was a Christian duty to tame the wild beasts (a concept we can equate to the missionary's impulse to convert colonized populations to the one true faith). While most continue today to accept our right to rule the planet, many would argue that we earn this mastery through superior intellect rather than divine right. Even this position has recently been challenged by moral philosophers like Peter Singer, who rejects the assumption that humankind stands alone at the top of the evolutionary model. Calling for a revision of this speciesism—that is, the belief, which he connects to racism, that one species is superior to all others—Singer urges us to reevaluate our relationships to animals based on our shared ability to feel pain. In light of such radical thinking, Robin Schwartz's images of interspecies bonding become themselves radical visions of a possible future where there are no longer animals in the wild, or an imagined past where all creatures lived in harmony. Her photographs skirt issues of mastery and subjugation: these encounters take place between equals in a space where the animal is at home (even if captive), and the human-child is a visitor. They also cannily avoid the easy stereotype of the feminine affinity with nature: there is no real nature in view, just the enclosed spaces of home, garden, farm, and yard.

Schwartz's interest in animals as a subject predates the arrival of her daughter, and is not simply the core of her photography but also a deep part of her personal life. Schwartz, her husband Robert Forman, and their daughter Amelia live with animals, and that easy familiarity with and acceptance of interspecies connections is embedded within the encounters collected in this book. These are not animals but individuals, with names and biographies that are often suggested by the details of the settings. We who do not know animals very well have been conditioned to see an image of one animal as a symbol for the species as a whole, but placing a single animal into a narrative that includes a child, a sofa, or a dining room decorated with images of monkeys changes that view and activates our reading of the animal as one of us.

Some of the animals are difficult to categorize as wild or tame. Some are wild but constrained by diapers and furniture; some, like Dillie the deer,

seem equally at home in a bedroom and out in the yard; some are family pets—but not run-of-the-mill family pets. Instead of familiar cats and dogs, we see hairless sphynx cats, Chinese crested dogs, and even a Janus cat named Frank and Louie, whose doubled face is tripled by a mirror held artfully by Amelia. Sometimes the uncanny erupts into full-blown strange: a sphynx cat with ancient eyes sits akimbo on an imperious toddler's lap, lemurs fly overhead, a tiny monkey pants with pleasure as Amelia breathes into her face, or a kinkajou's pink tongue extends beyond all reasonable length.

The stories these images tell turn on similarity and difference, located in the space between the photographer's vision and the performance enacted by the child and her animal companions. They show us attachment and detachment, silence and the solemnity of ritual, gifts offered and received. Undeniably these photographs are collaborations between the photographer, her models, the human caretakers of these animals, and artworks that visualize human relationships with the animal world: Egyptian goddesses and their cats, Gustave Courbet's *Woman with a Parrot*, Leonardo da Vinci's *Lady with an Ermine*, Frida Kahlo's *Self-Portrait with Monkey*.

An enormous weight of personal investment in these photographs is also felt in the photographer's desire to hold on to fleeting time. Many layers complicate and amplify the images, taking them beyond portraiture, but one of the subtexts of this series is the passage of time, which is so much more visible when a child is in focus. There is poignancy in seeing Amelia grow from a toddler to a self-aware young woman, while the animals—primates most clearly—remain in a state of perpetual childhood. Children, unlike pets or any captive animals, move from dependence to independence, and both parent and child must find ways to let go. Can we read these photographs of such extraordinarily beautiful creatures, the child included, as anything less than a meditation on time, change, and the loss of innocence?

This book is dedicated to Amelia, my daughter, and to Little Amelia, the capuchin.

In memory of my mother, Helen Schwartz.

There is so much to acknowledge in making the Amelia and the Animals series and this Aperture book. Above all, I am grateful to have a daughter who has developed the enormous fortitude to meet animals and people, and to make thousands of photographs with me. I attribute our memorable experiences to Amelia's ingenuity in relating to each individual animal with kindness and respect. (It's important to me to note that these are photographs of Amelia and the animals connecting with each other, and that no animals have been photoshopped into the frames in any way.) Amelia's collaboration with me and with the animals enhanced our photographs. I am so proud of my strong and beautiful daughter, and of who she has grown up to be. These fifteen years of motherhood were often shadowed by a whirlwind of work and deadlines. In retrospect, this series represents the most significant era of my life, and became a lifeline to my child.

I am thankful to the generous caretakers of the much-loved animals who gave Amelia and me the adventures of a lifetime: journeys with our beloved primate friends of all kinds; elephants; cats, big and small, including one with two faces; deer; kangaroos; a baby bat; goats; coatimundi; foxes; a wallaby; llamas; alpacas; a mongoose; sheep; horses; ponies; rats; ferrets; an armadillo; an opossum; emu; skunks; rabbits; an iguana; a camel; snakes; tortoises; donkeys; giraffes; zebras; an assortment of birds; and, of course, our dog friends.

There are so many "animal people" to specifically thank, each of whom trusted us with their one-in-a-million, wonderful animals. Thank you for allowing me to visit repeatedly: Pam, Heather, Connie, Marty, Michelle, Ramon, Mary, Melanie and Steve, Cindy and Tommy, Sandy (RIP), Emily, Ken, Julie, Sue, Sherry, Karen, Giovanni, Vanessa, Jessica, Molly, Elizabeth, Walter, Robert, and Michael. Thank you to my dear whippet friends, Linda McDonald and Jackie Hilsky, for always being there for my family. Above all, I owe so much to my friend Alison Pascoe Friedman, mother to Hannah and Sam. I photographed Hannah for years as a companion to Little Amelia, the capuchin after whom my Amelia is named. Alison and the remarkable Little Amelia helped me begin and continue two long-term projects: *Like Us: Primate Portraits* (1993), and the Amelia series in its entirety, which has resulted in two Aperture publications—*Amelia's World* (2008), and now this book.

Thank you to my husband, Robert Forman, for trusting me on what must have seemed like crazy road trips, and for pushing me to keep doing what I loved. You showed me by example how to be a dedicated artist. I could not have accomplished this project while parenting, having my animals, and working toward university tenure without your support. I so appreciate our family and evolving sets of animal companions.

I am so appreciative to Donna Gustafson, curator at the Zimmerli Art Museum at Rutgers University, for writing the insightful essay included in this book, which gives context to my work beyond photography, and for having edited my writing throughout the entirety of the Amelia project. Thank you to Elizabeth Krist, senior photo editor at *National Geographic*, for boosting my confidence and teaching me how to make a presentation—you really did change my life. Vince Musi, there is no other photographer who is as generous as you are. Thank you for inviting me to present at the LOOK3 Charlottesville Festival of the Photograph, which was a big deal for Amelia, too. Candy Pilar Godoy, you tried to teach me organization; you and Miki Meek were both wonderful in helping me edit my photographs. Thank you to Elaine Goldman for your unwavering support.

I am privileged to be part of the Aperture family. My deepest gratitude goes to Kellie McLaughlin, for consistently being my advocate throughout the years, and to my publisher and editor Lesley Martin, for her generosity and forbearance, as well as to Samantha Marlow, for her supreme patience. Jason Bailey and Barbara Escobar, you are both magical, and thank you, Chris Boot, for listening to me at the *National Geographic Magazine* Annual Seminar and for giving me this shot.

Finally, I'd like to thank all of the new supporters from the Kickstarter community who helped make this work possible. I am truly grateful to have this book; above all this is my gift to my daughter.

KICKSTARTER SUPPORTERS

Victor Alcantara; Lauren Alyssa; Kristen M. Amato; Ellen Amel; Andrea, Jamie, & Tupaw; Marie Arago; Joseph Arenas; Holly Bailey; Joe Baio; Rachel Baker; J. Kevin Barton; Lauren Barwood; Jens Bauer; Essie Bee; Marion Belanger; Stephanie Berger; Emilia Bergmark-Jimenez; Teresa Bleser; Phil Block; Nancy Borowick; Malcolm Bowles; Erin Brethauer; Nancy Brokaw; Luc Busquin; Debbie Fleming Caffery; Eneida Cardona; Alejandro Cartagena; Madeleine Casey; Jamie Cerretti; Pamela Chen; Vincent Cianni; Susan Ciccotti; Germaine Clair & Brooks Johnson; Robert Clark; Paul Colarusso; Kelli Connell; Sb Cooper; Nina Buesing Corvallo; Pamela Cox; DeShaun Craddock; Kelsey Crowe & Georgia Brown; Cubby & Ginger; Terry Dagradi; Beth Dallam; Carol S. Dass; Rocio De Alba; Carlos Loret de Mola; Aroldo de Rienzo III; Emily J Denlinger; Derek "Trouble" Duff; Paul Edwards; #ellethedog; Amelia Arrow Egstleston; Judith Glick-Ehrenthal & Herb Ehrenthal; Katrin Eismann; Jon Feinstein, Humble Arts Foundation; Elle, Ari, & Josie Felderman; Char Lynn Ferguson-Lea; Donna Ferrato; Jean Ferreri; David Fisher & Pearl Beck; Ellen Forman; Alexander Fricke, Heppenheim (Germany); Judith & Julia Friedman; Shauna Frischkorn; David F. Gallagher; Sophie Gamand; Patricia Garcia-Gomez; Wendy Given; Bud Glick; Rebecca Glick & Anne Hoskins; Audrey & Harvey Glick; Melissa Golden; Elaine Goldman; Stephanie Gonot; Nate Gowdy; Lee Grant; Toni Greaves; William Green; Joshua Dudley Greer; Liz Grover; Natalie Gruppuso; Sharon Guynup; Romina Hendlin; Maryellen Hendricks; Pamela Herou; Michael Hoeh; Joseph O. Holmes & Sara Bennett; Chris & Evgeniya Hoover; Sarah Jane Horton; Timmy Huynh; Ahmer Inam; Lizabeth A. Johnson; Dave Jordano; Russell Joslin; Rachel Forman Justus; Soufyan Al Kabbani; Laura Kane; Suzie Katz (PhotoWings); Pat Kepic; Paul Kessel; Melissa & Josie Kestel; Emma Kisiel; Charity Kittler; Richard & Sydney Krelstein; James Kyoon Yun; Erika Larsen; Gillian Laub; Jackie Lee; Zun Lee; Sarah Leen; Heather Liebler; Meaghan Looram; Lysie & David; Nancy Marion; Joe Marshall; Gina Martin; Lesley A. Martin; Matt McDaniel; Laura McDonald; Linda McDonald; Kate McElwee; Kellie McLaughlin; Stacy Arezou Mehrfar; Mark Menjivar; Alice Marie Milkovich; Ryan Mills; Lindsay Morris; Shelly Mosman; Annie Marie Musselman; Scott Neumyer; Lane Nevares, Nevares Fine Art; Nathan Noland; Landon Nordeman; Allison O'Keefe; Oliver, Masala Mutt; Shelley Padnos & Carol Sarosik; Kristen Palana; Gillian L. Peden; Ronald Perel; Sam Peters; Carlo Pirrongelli; Graham & Geneva Pobjoy; James Pomerantz; Alexandra Proba; Suzanne Revy; Susana Raab; Julian Rad; EJ Rappaport; David Reilly; Charles P. Rhoads; Witold Riedel; Saul Robbins; Samantha Rose; Claire Rosen; Kate Rosenberg; Robert J. Ross; Susan Sabatino; Ben Salesse; Rachael Dealy Salisbury; John Saponara; Leigh Shirley-Sims; Sarah Small; David Solo; Leslie E. Sorenson, PsyD; Jan Staller; Paula Steinberg; Andrea Stern; Marty Stevens; LaNola Stone; Jessica Talos; Amanda Taylor (aka Katie & Allie's mom); Sweehuang Teo; Sara Terry; Hank Willis Thomas; Sarah Thompson; Peter Tran; Frances Tuite; Ninoska Viggiano; Anna Vinter; Jeffrey Vock; Donna Walcavage; Jessica Walsh; Neely Waring & Champ; Scott Witt; Susan Worsham; Amy Yenkin; Diane Zeitlin; Marco Zeno; and Minna Zielonka-Packer.

Robin Schwartz (born in Passaic, New Jersey, 1957) earned a master of fine arts in photography from Pratt Institute. Earlier work from this series of photographs was published in Schwartz's third monograph, *Amelia's World* (Aperture, 2008), edited by Tim Barber.

Schwartz's photographs have been published in the *New York Times Magazine*, *New Yorker*, *TIME*, *TIME's LightBox* blog, *New York Times Lens* blog, *Slate Magazine*, *PetaPixel*, CBSnews.com, *Guardian*, *My Modern Met*, *O*, *Photo District News*, *Fader*, *Juxtapoz*, *Stern*, *Liberation*, *H*, *Bang*, *Esquire*, *Marie Claire*, and the *British Journal of Photography*, as well as in books such as *Photography Speaks: 150 Photographers on Their Art* (2005); *Photographing Childhood: The Image and the Memory* (2011); and *Hijacked Volume I: Australia and America* (2008).

A full-time associate professor of photography at William Paterson University, Wayne, New Jersey, Schwartz is also on the faculty of the International Center of Photography, New York. She lives in New Jersey with her husband, artist Robert Forman, daughter, Amelia Paul Forman, and five companion animals.

Donna Gustafson (essay) is the Andrew W. Mellon Liaison for Academic Programs and Curator at the Zimmerli Art Museum at Rutgers University, New Brunswick, New Jersey, and a member of the graduate faculty in art history. Her recent exhibitions include *Striking Resemblance: The Changing Art of Portraiture*; *Lalla Essaydi: Les Femmes du Maroc*; and *at/around/beyond: Fluxus at Rutgers*.

Amelia & the Animals
Photographs by Robin Schwartz
Foreword by Amelia Paul Forman
Essay by Donna Gustafson

Cover: *Lorenzo*, 2011
Case cover and endpaper sketches
by Amelia Paul Forman

Editor: Lesley A. Martin
Designer: Deb Wood
Production Manager: Matthew Harvey
Production Assistant: Luke Chase
Senior Text Editor: Susan Ciccotti
Assistant Editor: Samantha Marlow
Copy Editors: Madeline Coleman and
Miranda Ottewell
Work Scholars: Jessica Lancaster and
Nina Perlman

Additional staff of the Aperture book
program includes: Chris Boot, Executive
Director; Sarah McNear, Deputy Director;
Kellie McLaughlin, Director of Sales and
Marketing; Amelia Lang, Managing Editor

Amelia & the Animals was made possible,
in part, with generous support from Laumont
Editions.

Compilation—including selection,
placement, and order of text and images—
copyright © 2014 Aperture Foundation,
Inc.; photographs copyright © 2014 Robin
Schwartz; texts copyright © 2014 Amelia
Paul Forman and Donna Gustafson. All
rights reserved under International and
Pan-American Copyright Conventions. No
part of this book may be reproduced in any
form whatsoever without written permission
from the publisher.

First edition
Printed by Graphicom in Italy
10 9 8 7 6 5 4 3 2 1

Library of Congress Control Number:
2014938755
ISBN 978-1-59711-278-9

Aperture Foundation books are
distributed in the U.S. and Canada by:
ARTBOOK/D.A.P.
155 Sixth Avenue, 2nd Floor
New York, N.Y. 10013
Phone: (212) 627-1999
Fax: (212) 627-9484
E-mail: orders@dapinc.com
www.artbook.com

Aperture Foundation books are
distributed worldwide, excluding
the U.S. and Canada, by:
Thames & Hudson Ltd.
181A High Holborn
London WC1V 7QX
United Kingdom
Phone: + 44 20 7845 5000
Fax: + 44 20 7845 5055
E-mail: sales@thameshudson.co.uk
www.thamesandhudson.com

aperture
Aperture Foundation
547 West 27th Street, 4th Floor
New York, N.Y. 10001
www.aperture.org

Aperture, a not-for-profit foundation,
connects the photo community and its
audiences with the most inspiring work, the
sharpest ideas, and with each other—in
print, in person, and online.